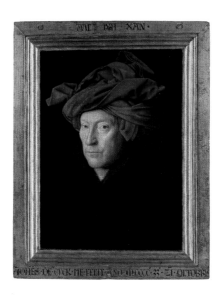

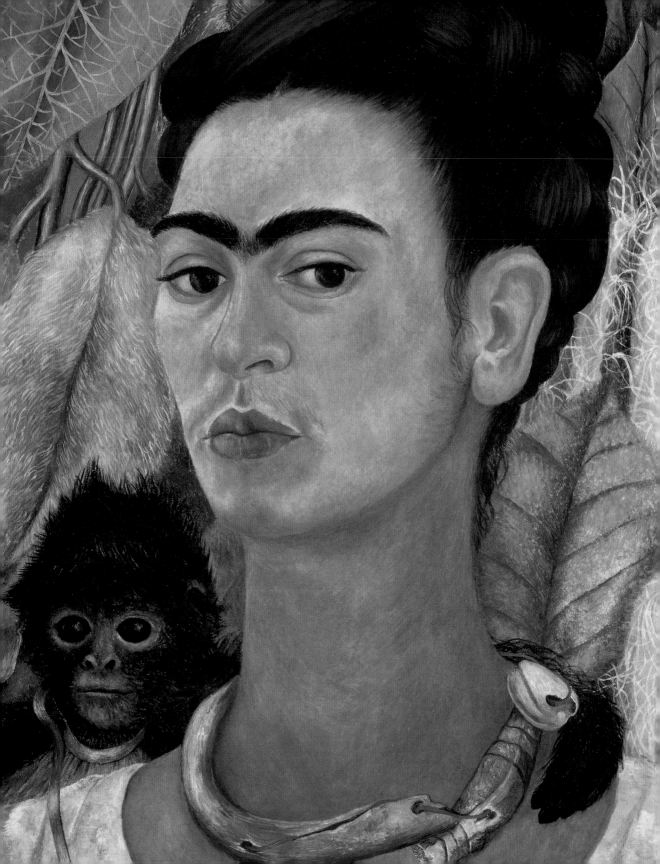

self-portraits

ERNST REBEL
NORBERT WOLF (ED.)

TASCHEN

HONG KONG KÖLN LONDON LOS ANGELES MADRID PARIS TOKYO

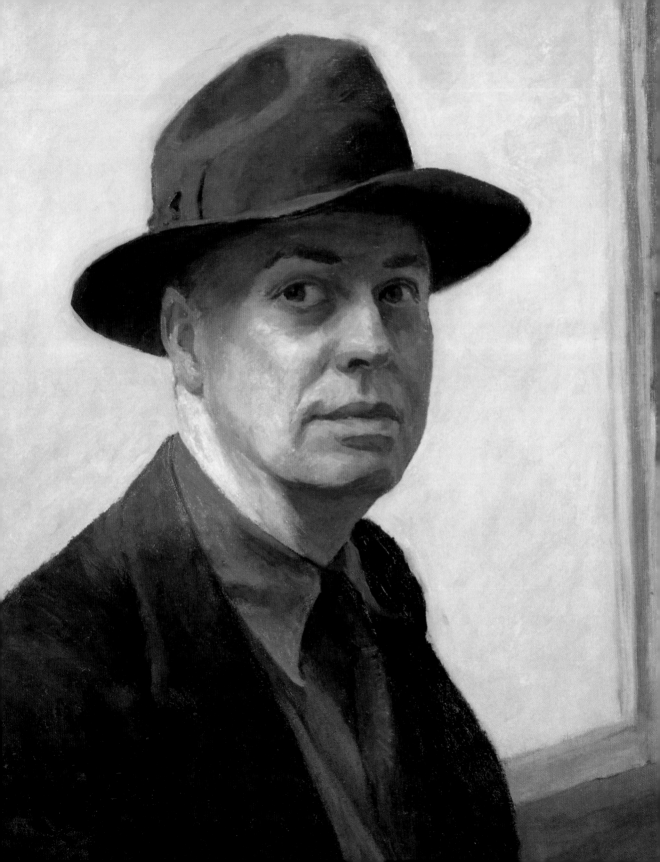

contents

Artists in the focus of their own eyes

The self – a mirror for everyone

A human eye (ill. p. 7). Close up. Pulled wide open it stares out of the picture. The iris a reflection of a cloudy sky, the pupil a black hole. What can this eye see? The out-there or the soulscape of the self? What does an artist see when he looks at himself in the mirror? Does he also see through himself to see us who are looking at him? Is an artist's self-portrait a medium of reflection or in the end only a black nothing, a "False Mirror", as the Surrealist René Magritte entitled his 1928 painting of the eye?

It is questions like these that have always made artists' self-portraits so fascinating. In a time of omnipresent media productions more questions arise as to the reasons for this fascination. Are the appearances of individuality and personality, when they speak to us from the world of art, more truthful than the human images we see on billboards, television and computer screens? An artist's self-portrait, does it bare the artist's self? Or does it only serve to represent society's conventional image of the artist's profession and status? There are many possibilities.

Self-portraits are testimonials in which the artist's ego as his own model and motif at the same time relates to other people. Artists depict themselves as they want to be seen by others, but also as they want to distinguish themselves from them.

Art history in itself also acts as a mirror and as a repository of all the information on the human image. For this reason art history allows us to ask the question which may be the biggest question we can ask, namely that of the impact and importance of our "selves". Those who delve into art history of course also learn to give up misapprehensions and prejudices, such as the incorrect notion that throughout history all those who painted pictures also always created depictions of themselves or that in every age those who produced paintings were always considered artists.

"Artist" is a relatively modern job description and status label. Strictly speaking it has only existed in the European cultural area since the 15th century. Previously those who created sculptures and paintings, wove carpets, made jewellery and instruments did so primarily as craftsmen, or sometimes, as with medieval illumination, as monks. Either way the work done, although it demanded special creativity, was

c. 740 — artist signature "ursus magister fecit" in the Abbazia di S. Pietro in Valle/Terni: possibly the earliest post-Antiquity stonemason's signature

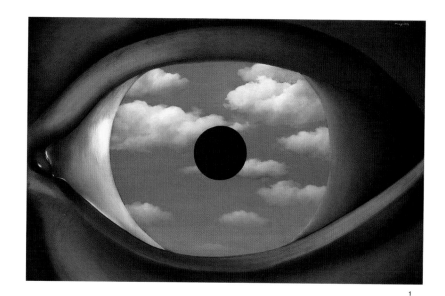

1. RENÉ MAGRITTE

<u>The False Mirror</u>
1928, oil on canvas, 54 x 80.9 cm
New York, The Museum of Modern Art

1

only rarely subject to personal decisions and goals, and in no way was it always subject to the set of rules that comes with specialized occupational training. The work was commissioned by collectives or created in the service of the rich and powerful, but its creator never worked under his own direction. Never? In the special field of self-portraits this self-direction started very early on.

Those who confront the large subject that is "self-portraits" today will not just witness a change in the bonds of society. They will be confronted in retrospect with intentions and achievements that belong in the domain of art itself. And they will always have to deal with the perils of their own consciousness, which has to interpret the historical contents in the spirit of the present. Only those who always look into their own mirror can find looking at historical self-portraits "exciting". Or conversely: those who are excited by studying old specimens will also find looking at themselves in the here and now informative. Both historical and present-day self-portraits or self-portrayals by artists help us to perceive what we now call "image", and not least our own.

I made this

When craftsmen creating art in Antiquity noted on their pottery, statue pedestals or friezes: "He made this" or even "I (followed by the name) made this", that initially was nothing more than the signature of a potter, a sculptor or a painter. These early signatures were surely written with satisfaction and even pride, as exclamation marks regarding an end result that would speak for itself. To this extent it would be fair to say they had a desire to be famous. Ancient authors such as Pliny or Cicero tell us that in those places where it was frowned upon for an artist *(optifex, artifex)* to want his name to be known by signing his works, he might use his cunning. Thus the painter Zeuxis is said to have had his name sewn in golden letters into the hem of his cloak. Or the sculptor and architect Phidias: according to Cicero, in order to secure his lasting fame, the master allegedly placed his own image on the shield of the huge Athena cult image he sculpted on the Acropolis, "because he was not permitted to inscribe his name". (Cicero)

It required certain social and intellectual circumstances for artists to make statements about themselves in their signatures. Me-

c. 840 — "Volvinus magister phaber", thus possibly the earliest goldsmith's signature, at the high altar in S. Ambrogio in Milan
c. 1120 — Master Wiligelmus applies his name several times to reliefs in the cathedral of Modena

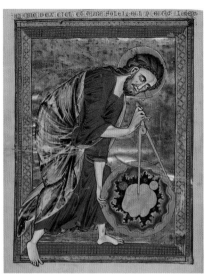

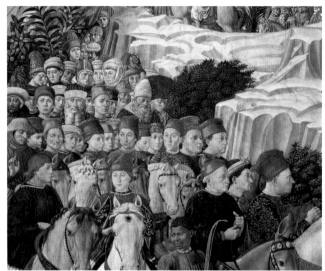

dieval artists, whether in a civic guild or in monastic service, differed in their voracity for fame and their ambition from their mythically inflated predecessors of Antiquity, but they were in no way entirely undemanding and selfless. In the initial letter or on the last pages in illuminated parchment books it is not uncommon to come across imaginative and elaborate self-portrayals by scribes and illustrators.

Even though art during the Middle Ages was primarily equated with craftsmanship, the images' transcendent character was never forgotten: namely when the model of the divine creation of the world was used for orientation. Two assumptions were contained in this. Firstly, human beings, created in God's image, carried the power of creation and creativity in them as a seed of divine creativity; human beings had the ability to create in common with their creator. Secondly: God's omnipotence and His creation could only be imagined with human means and measures, i.e. in images. God was seen as *artifex*. The world he created is the real work of art. It resembles a building that contains everything beautiful, every manifestation and expediency or a book containing all the world's truths. God's designing, measuring mind could thus be compared to an architect's endeavours (ill. p. 8), his cre-

ative action to the use of dividers, ordering every detail in heaven and on earth. All life, all beauty and spirituality, of which earthly buildings, figures, images and jewellery are only a pale reflection, all carry the signature of the supreme artist, of the *deus artifex.*

Where such exalted comparisons were made, people mainly thought of architects and less of painters or writers, since the *architector* who constructed and calculated with numbers and dimensions was more a worker-by-brain than he was a craftsman. Until the 15th century glass-painters and goldsmiths still ranked higher with their "light-drenched" activities than those monks and citizens who dared sign their pages, wooden panels or walls with their painter's names.

By the end of the 14th century for "small craftsmen" to sign their works was no less unwanted than the striving for fame this attested to. Thus, although the northern Italian jurist and humanist Benvenuto da Imola was able to sum up about the poet Dante Alighieri "that the demand for fame is to be found to the same extent in all human beings" he was surprised "that even small craftsmen fervently aspire to obtain it. And thus we see how painters are putting their names on their works."

1135 — Master Niccolo, it says in an inscription, was the name of the creator of the sculptures at the western portal of the cathedral in Parma
1178 — Relief with the Descent from the Cross by Benedetto Antelami, Parma, cathedral: the first time an artist's full name appears

2. ANONYMOUS ILLUMINATOR

God the Geometer
(from a Bible moralisée)
France, c. 1230, parchment,
34.4 x 26 cm
Vienna, Nationalbibliothek, Cod. 2554, fol. 1v

3. BENOZZO GOZZOLI

Self-portrait (detail)
in the "Procession of the Magi"
1459, fresco
Florence, Palazzo Medici Riccardi

4. LEON BATTISTA ALBERTI

Self-portrait medal
(execution by Matteo de Pasti)
c. 1450, diameter 9.3 cm
Paris, Musée National du Louvre,
Cabinet de Médailles

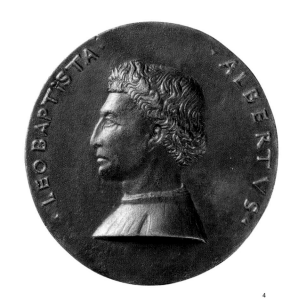

4

Like me

Peter Parler (1330–1399) was an *architector* and *sculptor* of high standing. He could dare to emphasize his work, position and amour-propre in a way hitherto unique in portrait history. When he, as the imperial and episcopal cathedral architect, placed a life-sized bust of himself in St Vitus Cathedral around 1375, he was the first artist, who, in addition to providing us with a signature, coat of arms and inscription, also gave us an image of his personal appearance (ill. p. 11). The gaunt man in his mid-forties with thin hair and a trimmed, lank beard, dressed in a simple cloak with the hood thrown back, has visibly made a "portrait" of his appearance, in other words has depicted his own natural attributes and characteristic qualities.

Another fact is however equally important. Parler incorporated his self-portrait into the select company of other neighbouring busts in the triforium over the ambulatory, a social elite, there to protect the cathedral, as a sacred and stately space, from above, as it were. They include the members of the imperial family, archbishops of Prague, building directors and master builders, and they operate as a high council that embodies the dignity of politics, faith and the commemoration of the dead. It was into this collegiate body that the planning, drawing, negotiating and sculpting architect Peter Parler incorporated himself with the claim to physical recognizability and eternal, venerable commemoration. From an art-sociological perspective his bust marks an early example of the rise a court artist generally underwent, and from a portrait-historical perspective the beginning of a new "realistic" imagery.

The connection of civic craftsmanship and courtly service also characterized the art of the Flemish painter Jan van Eyck (c. 1390–1441) a generation later. Around 1430 he was both the chamberlain of Philip the Good, Duke of Burgundy, and city painter in Bruges. More advanced in his artistic self-confidence than Parler, van Eyck applied his social rank to the questions of the fidelity of an image and likeness of a portrait in a sensational new way.

His painting, dated 1433, (ill. p. 1) is probably the first autonomous self-portrait painting in European art. On the surviving original gilt frame the signature, date and motto leave a highly important message. Written on the top bar is a modest and proud "ALS ICH

1180 — Bronze door by Bonnanus in Pisa cathedral 1181 — Verdun Altar, Nicholas of Verdun, Klosterneuburg
1208 — Founding of the first German painters' guild in Magdeburg

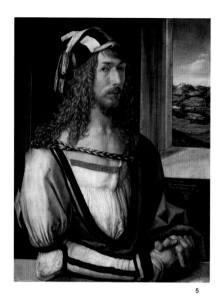

5

"ꜰor the more we can do,
the more we are compared
to the divine image."

Albrecht Dürer, c. 1512

CHAN" in Greek letters: "as (well as) I can". What this means, we are shown by the painting itself. From a dark background a meticulously modelled half-profile brightly emerges. The eyes are calm and alert, turned towards the beholder. On the head the bright red strips of fabric belonging to a turban are draped in a complicated manner in order to demonstrate the representation of material texture and three-dimensionality on a flat surface. The painter proves with the folds, the stubble and the tension in his facial expression that he "can" do what he shows. In addition, since all of the details of the skin and the cloth relate to a self in the mirror, the likeness is not just confirmed by the affirmation of identity in the frame's inscription, it is enhanced as a document of art. Thus van Eyck's comment can firstly be understood as a motto of a desire to achieve and to matter: I am what I can! Secondly the comment emphasizes the desire for honourable classification: I show my ability in the golden frame of my professional and social standing.

At the same time, around 1430, artists in northern Italy were working on other ways of presenting likenesses. Educated in the characteristic profiles such as could be studied on the old Roman imperial coins, the painters dared to use them on contemporary portrait medals.

In Florence Leon Battista Alberti (1404–1472) designed his self-portrait for a cast medal in this way (ill. p. 9), even though he was primarily a theoretician, not a practitioner, of the visual arts. But then he was so many other things too: humanist writer, co-inventor of the central-perspective construction method, architect and architectural theoretician, author of the first modern treatise on painting, author of an instructional book on sculpture as well as someone who dabbled in painting.

All human beings have their own unique profile. Depicting it means capturing the person accurately and finding their individual formula. Those who can even model the likeness formula on medals can hope for posthumous fame in the way the ancients defined it. It gives their existence a monumental "profile" both in the literal and in the figurative sense. Another thing that was desired was a certain idealization of the individual nature, on the model of the ancient specimens. Capturing the natural likeness is one thing; correcting it, exaggerating it through idealization, is another.

c. 1235 — Villard d'Honnecourt's sketchbook acts as an individual architect's portfolio

c. 1250 — In England the monk Matthew Paris is named as the illuminator for several manuscripts

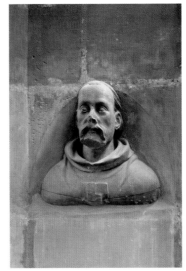
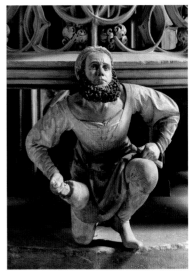

5. ALBRECHT DÜRER
<u>Self-portrait</u>
1498, oil on wood, 52 x 41 cm
Madrid, Museo Nacional del Prado

6. PETER PARLER
<u>Self-portrait bust</u>
c. 1380, sandstone, life-size
Prague, St Vitus Cathedral, triforium

7. ADAM KRAFFT
<u>Self-portrait at the Foot of the Tabernacle</u>
c. 1496, sandstone, life-size
Nuremberg, St Lorenz

6 7

peripheral and central

In the 15th century painters' and sculptors' self-references and self-esteem could not be depicted autonomously as long as the arts themselves were bound between courtly favour and civic guild obligations. To assume that self-portraits could have expressed the desire for complete self-emancipation is tempting from the standpoint of modern thinking, but it does not accord with the historical facts, as it initially contradicted the modesty that befitted the status of craftsman.

Benozzo Gozzoli (1420–1497) was not in the first rank of early Renaissance Italian painters, but his reliability and diplomatic skills put him on familiar terms with the powerful people of his time. There is a letter still extant in which he dared to address the exalted Giovanni de' Medici as "my dearest friend". When Gozzoli was commissioned in 1459 by the Medici banking family to decorate the walls of their personal chapel in their city palace in Florence with frescoes, he showed perfectly how an artist of that time could combine the modesty required of him with the self-portrayal desired by the artist himself. The *Procession of the Magi,* which depicts many figures, contains numer-ous more or less disguised portraits of contemporaries, only a few of whom can still be identified today. A single head amongst many, somewhat to the side and in the middle distance, is the only one to be wearing a cap with an inscription of a name (ill. p. 8). It reads "opus Benotii", in other words, "the work of Benozzo". The individual, characterized by keen eyes and a critical furrowed brow, did not want to drown in the sea of faces. He was trying not to be too forward, but still recognizable, defying time and oblivion. Viewers should see Benozzo both as included in the painting as well as on his own: doubly recognizable by the inscription and his individuality, as a member of Florentine society, and identified as someone who knows his place.

Double interests like this could also be found in German art after 1490. The man who stands out clearest here is Albrecht Dürer, who will be discussed later. His Nuremberg contemporary and fellow artist Adam Krafft (1455/60–1509) found a special solution, choosing to portray himself using his entire, life-sized body. At the foot of the 18-metre stone tabernacle in the choir of St Lorenz, the sculptor (ill. p. 11) presents himself as someone who wants to do many things at once: kneel down, creep out, carry a load, stand up. The bearded

1259 — Nicola Pisano completes the marble pulpit in Pisa cathedral: signed with "docta manus" ("knowledgeable hand")
1282 — First documented proof of a court artist, namely in Naples

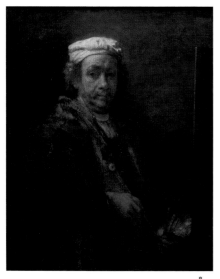

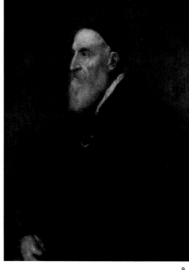

8 9

man in worker's clothes, tools in both hands, stares past the viewer with a strained glance up to the church's ceiling. In this way he vividly embodies what he thinks of himself and his work, namely that he was taking on a task that required all of his strength (indeed in German his name means strength!), but which also consisted in using the craft of the stonemason to chisel out the stone architecture that rested on his shoulders so as to make it light and airy.

Another example is Dürer's pupil Hans Baldung Grien (1484/85–1545). The reference now is more clearly to a central position for the artist's self-esteem and importance. In the central panel of the 1507 St Sebastian altar is the painter, isolated from the executioners, close behind the martyr himself (ill. p. 14). An elegant young man, fashionably dressed, wearing the cap of the "urbane" city-dweller boldly pulled down over his forehead. Like the martyr beside him the painter, as if he were the only real and worthy witness, peers out from the picture, his eyes calm and cool as they look at the beholder. In the consciousness of his presence and at the same time his distance he has stepped into the midst of his own work. Only the fact that he is dressed up as one of the actors of this event saves him from the ac-

cusation of arrogance. In any case the painter has documented that he knows how to exploit the scope accorded to him and in the process is trying to improve his status. Times have changed. Painters are more and more aware of the quality that occupied the highest rank of creative activity in Antiquity: the claim to *ingenium*.

creative "ingenium"

In European art history the 15th century encompasses the phase of those changes that allowed religious images to evolve into autonomous works of art, the craftsman-*artifex* to become an independently thinking artist, and self-representations serving merely a documentary function to grow into systematically developed self-portraits of the artists. The term "Renaissance" was coined for this change, it became the keyword for very comprehensive innovations in different areas.

Contemporaries with a humanist education (including artists such as Alberti, Ghiberti, Filarete, Leonardo and Dürer) sought a new

1304 — Giotto possibly paints a portrait of himself in the midst of the elect in the Last Judgement fresco in the Arena Chapel in Padua
1329 — Giotto receives the title of "protopictor" (first painter) at the court of King Robert of Anjou in Naples

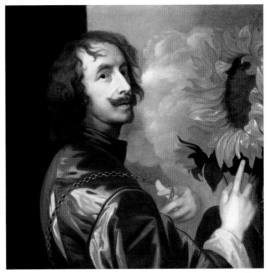

10

openness to the world, accepted the new risks that came with experimentation and, not least, demanded new social and moral self-determination. All of these things together were to make possible the break-out into a new "Golden Age". Particularly in regard to the painters and sculptors, their creations and designs were thought to depend on the same inspiration previously only conceded to philosophers, poets and musicians. The separation between everyday activities *(artes mechanicae)* and liberal arts *(artes liberales),* which had been customary since Antiquity, could no longer be strictly adhered to, since after around 1430 the art of painting, as long as it was only done at the highest possible intellectual level, counted as one of the exclusive activities of the cultured virtuoso.

This opened up all kinds of different paths. As a result self-portraits were able to rise to be manifestos of general human self-knowledge, even to the height of cultural self-reflexion.

Albrecht Dürer (1471–1528) from Nuremberg played an exceptional role in this long emancipation process and not just for German art, but also beyond Germany's borders. His 1498 self-portrait (ill. p. 10) represents the first fully-recognized painting achievement within his œuvre. If one were to look for historically early examples in which the Renaissance painter's desire to inspire and pride in his success both equally clamour for expression, one would emphasize this picture and place it in direct succession to van Eyck's ALS ICH CHAN.

Of course Dürer expanded on his Flemish predecessor. The half-length portrait in three-quarter profile against the view from the window shows us a young man in sophisticated dress, whose folded hands in smart leather gloves evince both humble composure and genteel equanimity. Gimps, braids, tassels, frills and long wavy hair are all signs that the man in the painting was a member of the young, urban elite. Our gaze, which takes us past him out into a mountain landscape far away, obeys the scenario of far-reaching intentions. A young painter, who has just risen to become an admired "virtuoso" in the art of woodcutting and copperplate engraving, considered himself as having "arrived" in every respect. Conceptually, socially, fashionably, and as a craftsman, he wants to be seen as completely modern. His monogram signature in the picture is an early example of a quality-seal and "logo". And if we consider that despite all the fashionable elegance

1357 — Nicolaus Wurmser from Strasbourg is the first to receive the title "pictor imperatoris"
(imperial painter), namely from Emperor Charles IV

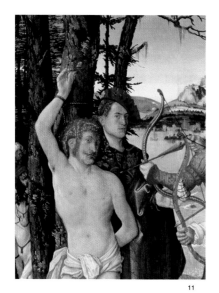

11

the face of the "German Apelles" is marked by a deep expression of Christian-religious seriousness of life, we will realize that the outward appearance is also making a moral assertion. Its motto: the art of painting is an *ingenium* given by God and strengthened by personal effort! Now Artists were what they demonstrated with their hands and their minds. After 1500, originality and innovation became indispensable as professional and personal characteristics.

When Bernardino Pinturicchio (c. 1452–1513) painted himself on a church wall in Spello in 1501 (ill. p. 15), he was not just playing with the standards of technical portrait likeness, which by then was taken for granted, he also flirted with his own image as image, with the artwork as a thing to be exhibited. It looks as if a portrait and an inscription tablet, both framed in gold, are hanging on the church wall together with a shelf arranged like a still-life, and in front a curtain throwing a shadow on to the frame and the masonry. However all of this is painted, it is nothing but paint on a wall, it is self-portrayal as a part of an all-embracing *trompe l'œil*. Put another way: it is not the self-portrait itself that is the pinnacle of artistic achievement, but rather its mise-en-scène.

A different extreme can be found in Andrea Mantegna (1431–1506) several years earlier. For his Mantuan funerary chapel he modelled himself in the shape of an ancient bust (ill. p. 15). The elaborate accord between the framing and the inscription, the tondo and the block, the bronze and the stone, incorporates a selection of media that had never existed like this before. The mere fact that a painter used sculptural means to create a funerary monument for himself is sensational in itself. However, that he then went on to glorify his face in the style of a Roman emperor goes beyond the conventions of the portrait genre. This kind of thing had previously only been found on medal portraits, like those by Alberti, but never on such an elaborate scale. A man with a leonine mane, dignified-heroic rage and lordly pride: all this embodies the height of rhetoric. Clearly his intention was to associate the commemoration of an artistic lifetime achievement with the veneration of Antiquity. Old and new art-history, model and ego were designed to come together for eternity in the middle of a Christian church.

--

1359 — First certain hidden self-portrait, that of Andrea Orcagna in Florence, Or San Michele
c. 1400 — For the first time Filippo Villani lists painting under "artes liberals" (the liberal, noble arts) in his chronicles of Florence

--

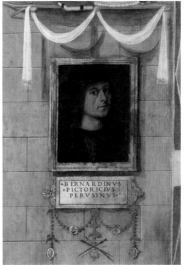

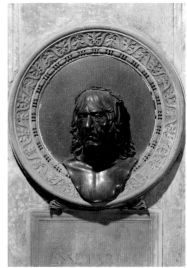

11. HANS BALDUNG GRIEN

<u>Disguised self-portrait</u>
in the "Martyrdom of St Sebastian" (central panel)
1507, oil on wood, 121.5 x 79.2 cm
Nuremberg, Germanisches Nationalmuseum

12. BERNARDINO PINTURICCHIO

<u>Self-portrait</u>
1501, fresco
Spello, S. Maria Maggiore, Cappella Baglioni

13. ANDREA MANTEGNA

<u>Self-portrait bust on a funerary monument</u>
c. 1490, bronze, porphyry, marble,
height 47 cm
Mantua, S. Andrea

12 13

Alone and in company

Neither before nor after 1500 did tendencies towards individualization fully exclude their counter-tendencies. Community and collective consciousness were part of the artist's profession. Everything started with the Medieval guild system. It was both a shackle and a chance, a condition and limitation of creativity in one. Guilds were self-administering communities of urban interest-groups, particularly of the craft and merchant professions. They developed in Europe together with civic culture from the 12th century onwards and remained in effect (with slowly waning political efficacy) until the 18th century, often under different names and changing influences. In Magdeburg it was the sign-painters who in 1206 were the first in German guild history to document co-operative affiliation in the form of a "guild of Saint Luke". In Venice the *artifices* formed a "brotherhood" in 1290, in Ghent the painters joined with the woodcarvers in 1338 and in Florence in 1339.

In these cases as well as in others the issues were not just the regulation of costs and earnings, competition and welfare. They were also about the compatibility of work and authority, about the nurturing of faith, morals and leisure pursuits. Without the group provided by the guild, an individual would have hardly had any professional prospects. However it worked the other way around too: without the collective institutions, painters' and sculptors' pride in quality and their legal claims would not have led to the historical threshold of individual success. Only around 1500, after the first boom in the printing of books and pictures had both demanded more from precisely the artistic professions and benefited them too, did these ties begin to loosen. The co-operative spirit of artistic living and working never entirely disappeared though, not to this day. Not even when, since Michelangelo, the socially highly valued egocentricity of the great individuals and loners was allowed to claim its own career styles.

From an early date, documented from around 1280, another opportunity of collective identification was created. It was founded in the position of the court artist. From the role of court artist a mentality emerged which affected both the isolation of the creative *ingenium* and the binding character of its claims, which were now also partly shaped by the aristocracy. Payment, pensions, titles of nobility and privileges all beckoned with both professional and personal prestige.

c. 1400 — Cennino Cennini pens a famous treatise for his painter colleague
c. 1430 — Earliest extant portrait drawings (Jan van Eyck, Pisanello)

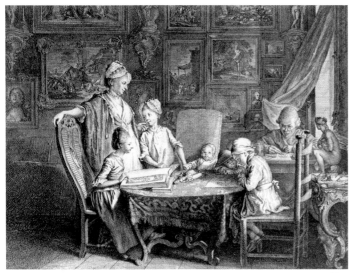

14. DANIEL CHODOWIECKI

<u>Self-portrait with Family at the Table</u>
1771, etching, 18 x 23 cm
Collection AKG

15. GIORGIO VASARI

<u>Self-portrait in the circle of artists associated</u>
<u>with Grand Duke Cosimo I de' Medici</u>
c. 1560, ceiling tondo in the "Sala dei Cinquecento"
Florence, Palazzo Vecchio

The flipside of this rise was the dependence on acts of grace and the whims of rulers, and entanglement in the rivalries of authorities and ranks. Thus it was a good thing if there was support from civic and private connexions. Many self-portraits tell us time and again about these conflicts between status, role, duty and inclination. We become witnesses to how the self-image also changes during this process, often in conjunction with the trends of the *zeitgeist.* Thus family, group ethos and friendship are given their own weight completely in the 17th century, while love and political comradeship had to wait until the 19th. A sign of exclusive recognition that remained constant over the centuries, sometimes with an almost legendary aura, was the dialogue between the artist and the ruler.

Their "Daedalian" relationship follows the theological model, where the artistic God *(deus artifex)* and the divine artist *(divino artista)* form an easy, confident analogy. In the same vein, after around 1500 rulers were able to see themselves as practitioners of the "art" of government, while a privileged court painter, sculptor or architect could see himself as "artist prince". The sense of creative superiority unified them across all class boundaries.

If Giorgio Vasari (1511–1574) was allowed to enter the innermost circle of artistic conversations centring on Grand Duke Cosimo I de' Medici, then forms of political and artistic propaganda were beginning to overlap (ill. p. 17).

Vasari was a typical 16th-century *uomo universale.* He became famous as a painter, architect, art writer, collector and academy founder. His commitment at the Florentine court served the patriotic glorification of state power as well as the propaganda of his personal artistic successes. At the foot of the princely circle of artists that naturally presents the grand duke in the centre as the supreme artist sits the man who himself did part of the painting, executed architectural changes to the palace and organized the exchange of ideas between the princely house and the international humanist public: Vasari. He sits with his back to us and thus expresses his detachment from the world outside of the court. By turning his head over his shoulder towards the beholder, however, he at the same time reveals himself as a propagandist of the Medici art policy. The artist as an inventive all-round virtuoso thus takes over the role of intermediary for the first time, and one who is literally "called" to the post.

1435 — Publication of Leon Battista Alberti's treatise on painting, the first surviving one of its kind,
in which he discusses central perspective in detail, amongst other things

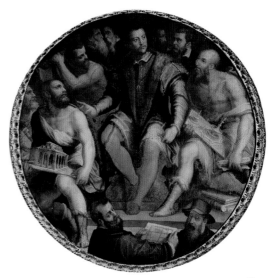

"Francesco was beautiful and had very graceful features, more like an angel than a human being, and so his likeness on this sphere was something divine... as also the shine of the glass, every reflection of light and shade was so individually and faithfully reproduced..."

Giorgio Vasari on Parmigianino's "Self-portrait in Convex Mirror", 1568

15

Decades later a court painter demonstrated how a ruler's praise and propaganda could even take on the character of a dialogue on equal terms. Anthony van Dyck (1599–1641) portrayed himself around 1635 as a nobleman in dialogue with a sunflower (ill. p. 13). None other than King Charles I of England is being symbolized thus. It has its head turned towards the painter (as if the painter were the sun!), thus showing his royal favour, while the painter is pointing to this turn with his right hand. At the same time he reaches to the gold chain of knighthood he had recently received from the king with his left hand. For his part the painter turns to look out of the picture. Artistic fame, knighthood, dignity and a dialogue with the beholder are all combined into a sophisticated manifold of twists and turns.

For the artist, the "community" consisted neither just of aristocratically aloof dialogue partners nor fellow practitioners bound merely by a common trade. Before 1750 the art public was a little-known entity. However, there were circles of friends, and family members were also part of the larger community. Thus in 1771 the respectable citizen, Prussian taxpayer, draughtsman, etcher and book illustrator Daniel Chodowiecki (1726–1801) portrayed his professional success as the result of hard-working personal modesty and an orderly family life. These were surroundings he knew, and which he could and wanted to trust. While removing himself into the corner as the hard-working observer (ill. p. 16), he let all the light fall on his family. In a studio living-space with many pictures hanging on the walls, his wife, daughters and sons crowd around their common table. They are studying, drawing and communicating affectionately and simply, they show themselves to be a morally intact community. Such a private idyll is demonstratively contrasted with the "wide world" of public life.

Identity and role

However, we have hurried too fast along the timeline. Solidity and freedom already appeared as allegorically inflated values in the self-portraits of the pre-Enlightenment era. Particularly where hierarchies and rank also determined the artistic vision of the world. Gender segregation was not excluded from this. Here we have to start our deliberations from another angle. According to their terminology artists

c. 1450 — Invention of printing
1471 — Leon Battista Alberti publishes the first artist autobiography

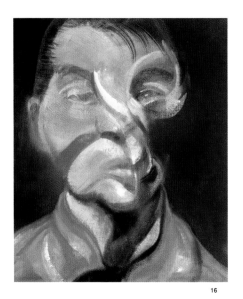

16

"…ᴀnguissola's several self-images in the act of painting were understood by contemporaries as embodying two "marvels," as the humanist ᴀnnibale caro put it: the rarity of a work created by a female, and a simulacrum of its prodigious creator."

J. Woods-Marsden, on the female painter Sofonisba Anguissola (c. 1527 – c. 1623), 1998

are male. Men produce works, women bear children. Correspondingly the old picture: men sat at the easel, women posed as models or as muses next to them inasmuch as they were not in any case running the household in the back rooms. It is only in the 20th century that art history can find a fundamental change in this role division. Nonetheless it is known that at least since the early 16th century there have also been female artists who influenced the productive activity in the studios and in individual cases they were even admired virtuosos. The 1548 self-portrait of Catharina van Hemessen (1527/28 – after 1583) is one of the early pieces of evidence (ill. p. 24). The small picture presented by the painter as an expression of gentle inwardness is also remarkable inasmuch as it is the oldest known example of a self-portrait "at an easel". A woman with all the signs of inspired creative power is looking in our direction: the inscription in Roman capitals, the easel, palette, maulstick and paintbrush form a cross.

Thus there were exceptions in the male-dominated history of art and moreover these exceptions were important. Quite a different exception, this time from a traditional point of view, is Tiziano Vecellio (c. 1485 – 1576), whom we know as Titian. He is unquestioningly con-

sidered one of the giants in the field and the first "painter prince" in art history. Here in the Madrid picture from around 1565 at the age of 80 (ill. p. 12) he chose an image for posterity in a fittingly memorable pose: his upper body in profile, marked by spiritual calm and utmost restraint. Everything is focused on the one eye and the one hand holding the brush handle. Even the double chain that marks the wearer as a nobleman (in 1533 Titian was elevated to count palatine by Emperor Charles V) first has to be discovered as a sign of rank in the dark of the painting. Evidently Titian wanted to unite social role and personal identity. He wanted to make the transience of bodily life just as visible as the possibility of intellectual survival through art.

When the "painter prince" Peter Paul Rubens (1577 – 1640) portrayed himself at the end of his life for the gaze of posterity, he also reconciled rank and demeanour (ill. p. 24).

Look at all the things this painter had achieved by this time! Nobleman, owner of a palace, secretary to the privy council of the king of Spain, busy diplomat at the major courts and the enterprising master of a whole apparatus of studios and engraving workshops; a bourgeois social climber turned nobleman. No painter was more

1473 — Earliest independent artist's studio and show-house: that of Andrea Mantegna in Mantua
c. 1490 — First printed self-portrait of a married couple, copperplate engraving "Israhel van Meckenem and Wife"

16. FRANCIS BACON
<u>Self-portrait</u>
1972, oil on canvas, 35.6 x 30.5 cm
Private collection

17. CASPAR DAVID FRIEDRICH
<u>Self-portrait</u>
1810, chalk on paper, 22.9 x 18.2 cm
Berlin, Staatliche Museen zu Berlin – Stiftung
Preussischer Kulturbesitz, Kupferstichkabinett

18. PAULA MODERSOHN-BECKER
<u>Self-portrait on her 6th Wedding Anniversary</u>
1906, resin tempera on board, 101.8 x 70 cm
Bremen, Paula Modersohn-Becker-Museum

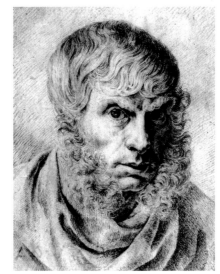 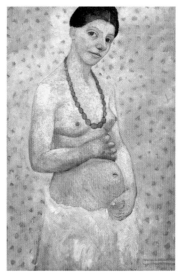

17 18

famous than he was around 1630. And thus the man who had grown old knowing fame and work longed for stability, for a permanent consilience between what he was and what he was allowed to think of himself. In a letter dated 18 December 1634 to a humanistically educated friend, a few years before he painted his last self-portrait, Rubens opened his heart. He described how, almost torn apart between ambition and duty, he initiated his withdrawal from courtly ties and had finally found himself: "At the peak of my favour… I made the decision to do violence to myself and cut this golden knot of ambition… Now I am… united with my wife and my children and have no other wish in the world anymore, but that I may live in peace."

The Vienna portrait depicts Rubens in a wide, dark cloak together with a column that rises powerfully at the edge of the picture next to his hands. His left hand, already bent by gout, is lying on the hilt of the rapier, but at the same time anxious to appear relaxed, while the right hand is in the elegant glove, a sign of distinguished noblesse. The column "stands" for dignity, strength and permanence. Under the lowered lids the artist's slightly ironic look appears tired, but also stoically composed.

Similar and yet quite different is his great Dutch counterpart and contemporary Rembrandt (1606–1669). Where Rubens preferred a powerful posture, Rembrandt displayed a broken, finely nuanced inner life. In the Paris portrait of 1660 (ill. p. 12) the painter, who by no means always saw the sunny side of life, gazes at us with a melancholy expression. Palette, paint brush and maulstick almost disappear in the dark space of the painted "inner mind". The humanist circle in Amsterdam, the city's art-collecting merchants and reformed clerics did not just accept the painter's insatiable desire for psychological, experimental self-interpretation, they marvelled at it, occasionally with confusion. The stage, costume and facial expression are only ever the external indicators in this endeavour. Rembrandt pursued self-observation as a method of questioning his identity with extreme means. Questions like: "Who am I really? What lies ahead of me?" maintain to this day a seriousness which is deeply internal and cannot be formulated from the spirit of merely outward likenesses.

Of course it was not just painters who addressed these questions in the 17th century. However, as commercially licensed experimental subjects of bourgeois morality, as it were, they were accorded

c. 1506 — Raphael's student Marcantonio Raimondi makes a reproductive print of a painting for the first time

c. 1507 — Earliest extant nude self-portrait, a drawing by Albrecht Dürer (in Weimar)

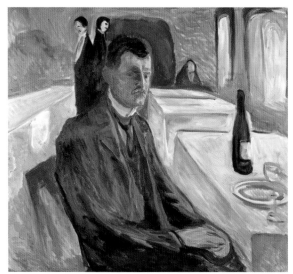

19

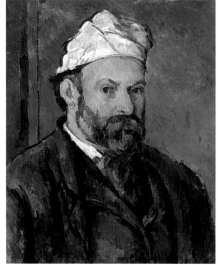

20

special rights. Unlike the sculptors working in three dimensions, painters have the dynamically open means of colour and tone available to them. Portraitists of the calibre of Rembrandt, van Dyck or Velázquez could thus translate the indefinable aspect of inner emotions into their work. Painting portraits means painting the subject's inner life by playing with the light and shadow on the surface.

In the 17th century this correlated with an increasing division of labour. There was hardly a painter who was still responsible for every subject matter. There were experts for history, still-life, landscape, for role portraits, for status portraits and group paintings. However, all of the specialists also always painted self-portraits, a factor that links them across all division of labour and areas of expertise. They all often painted themselves in their studio, because here they could combine allegorical actions, a familiar ambience, meaningful decor and masked appearances. They also always painted themselves in front of a mirror. The mirror is the visually indispensable authority on the truth of all of the movements and transformations.

mirror and studio

We can go even further: in actual fact it is the mirror that has been the instrument of self-observation and self-interpretation since the 15th century. It acts initially as a medium of the design process, then as the imaginary focusing of those looks every self-portraitist expects. It is a social reflection of the here and now as well as of the imagined future. And at no time was this gaze from the picture handled more ambivalently and more pregnant with self-reflexion than during the Romantic age.

The Romantics considered reflections in the mirror as the self seen as the result of a split, as fleetingly objectified inwardness par excellence. Caspar David Friedrich (1774–1840) was amongst the leading masters of this enhanced subjectivity around 1820. His self-portrait drawing in Berlin presents him as one in search of the world and as one who examines himself (ill. p. 19). He stares at his reflection with probing eyes. The bright side and the dark side of the face portrait the day side and the night side of dreaming. However he studies himself tensely, as a productive shaper of the inner gaze. Caspar David Fried-

1550/68 — Vasari's "Vite" (in first and second editions): first art-history work, written by an artist

1610 — Rubens acquires his Antwerp house and extends it into the first villa of a "prince of painters"

19. EDVARD MUNCH

<u>Self-portrait with Wine Bottle</u>
1906, oil on canvas, 110.5 x 120.5 cm
Oslo, Munch-Museet

20. PAUL CÉZANNE

<u>Self-portrait with a White Turban</u>
c. 1882, oil on canvas, 55.4 x 46 cm
Munich, Bayerische Staatsgemälde-
sammlungen, Neue Pinakothek

21. FRÉDÉRIC BAZILLE

<u>The Artist's Studio, Rue de la Condamine</u>
1870, oil on canvas, 98 x 128.5 cm
Paris, Musée d'Orsay

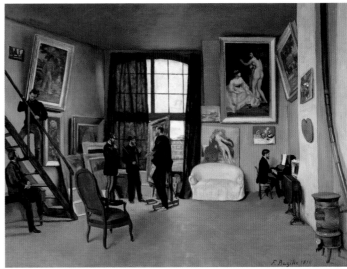

21

rich never entered the stage of public life. He worked, brooded and created his melancholy, anxiously God-trusting landscapes in almost monastic seclusion.

If the mirror is the instrumental focus of reflection, then the studio is its architectural focus. Since the 16th century the artist's studio, as far as it is shown in self-portraits, has acted as a multi-purpose room of moods and world designs. It is the artist's living space, work space and a museum-like place to study and retreat; then from the 17th century onwards it increasingly becomes a site of theatrical staging and finally a place for meetings with friends and intellectual confrontations. Studios can be furnished in a bourgeois manner or they can be available ready-furnished in a monastery or at court. Only after 1850 did they constitute a special-purpose room, with high windows, gallery, a living corner and storage space, usually in the attic-region above the city, where the light is better and the rent cheaper.

Studio pictures between 1550 and 1900 emphasized their interior character either in a genre-like narrative way or a circumstantial-ceremonious manner, depending on whether they were to be seen as practical ambience or idealized location. The personal focal point in the midst of his utensils and decor is of course the artist himself, usually standing at an easel, either concentrating on himself or searching for direct eye contact with the beholder. In addition the studio owner could be surrounded by company: noble visitors, models, family members, fellow-artists, merchants.

In the 19th century the number and programmatic facets of the studio scenes increased. Frédéric Bazille (1841–1870) is one example amongst many. His painting studio in Paris in the rue de la Condamine (ill. p. 21) is all in all more a portrait of the studio than of the painter. With its date of 1870, it calls up an artistic self-image on the brink of modernity. Here the artist did not choose Daedalian solitude for his self-portrait, but a scene containing several people. Fellow-artists and friends surround the painter at work, they are making music or have withdrawn to the corners to have conversations. Paintings hang on the walls as a show of the artist's work or as example material. Through the high window we can look out on to the roofs of Paris. We are meant to see the intellectual height of a profession that has its exclusive space, but that also grants access to those who want to move upwards towards art.

1648 — The Paris Academy is founded
1787 — Wilhelm Heinse's "Ardinghello" is the first novel about an artist

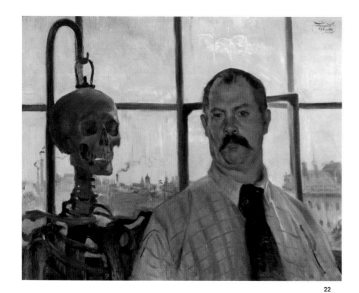

22

"Every portrait that is painted with feeling is a portrait of the artist, not of the sitter. The sitter is merely the accident… it is not he…, it is rather the painter who, on the coloured canvas, reveals himself."

Oscar Wilde, The Picture of Dorian Gray, 1891

From the immobile studio to the mobile camera, from the mirror on the wall to the camera in the hand: these are the paths of the future. Nothing changed the development of the visual arts in the 19th century so profoundly as the triumphal march of photographic inventions. While technical apparatus has never been able to replace manual creativity, but has rather supplemented and inspired it, after 1860 it certainly became a competing medium, particularly in the matter of depictions of people that aimed at likeness. Since the invention of photography, painters, sculptors and architects have portrayed themselves differently from how they did before. They are inspired by the unaccustomed objective precision, expect a new speed of seeing and recording, experiment with perspective jumps, random cropping and motif manipulation. Photography is the new mirror of art and artists, a mirror that takes on an independent mechanical existence. Documentation now accompanies fiction on equal terms. On the other hand the painter's "view" switches by default to regions of the world and of pictures that are still unknown.

When Paul Cézanne (1839–1906) put paint to canvas, many of the above-cited changes were already reflected in his work (ill. p. 20).

For him painting has become a fully valid act of *réalisation,* parallel to the coming into being of nature, parallel also once again to the law of divine creation. Partly in dialogue with thoughts about technological civilization, partly in conscious opposition to it, Cézanne began to work on the possibilities of "pure seeing" and "pure painting". Consequently he entered the niche that photography was not yet able to fill. Patches of colours on the picture, which may refer to both figures and spaces, regulate themselves in a musical way in Cézanne's work, as a "modulation" of the visual impressions translated into abstract elements. They now form an independent reality of poetic relationships of form. Painting can thus once again distance itself from the technical medium. The painter's broadened palette corresponds to a professional self-image that too has become wider. At the height of specialization the painter is now almost everything: craftsman, businessman, scientist, educator, poet, engineer, philosopher. He or she is a citizen, a recluse, a bohemian and intellectual aristocrat. Lastly, a few award him or her a special rank, for which until now there has never been a hierarchical or professional title: anti-citizen, magician, prophet and avant-gardist.

1828 — Dürer-festival in Nuremberg, first modern artist festival with cult character

c. 1830 — The artist colony of Barbizon is founded, early example of such an institution

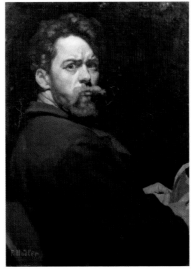

22. LOVIS CORINTH

<u>Self-portrait with Skeleton</u>
1896, oil on canvas, 66 x 86 cm
Munich, Städtische Galerie im
Lenbachhaus

23. FERDINAND HODLER

<u>Self-portrait of the Artist in a Rage</u>
c. 1881, oil on canvas,
72.5 x 52.5 cm
Bern, Kunstmuseum

24. VINCENT VAN GOGH

<u>Self-portrait</u>
1889, oil on canvas, 65 x 64 cm
Paris, Musée d'Orsay

23

24

Nurturing the myth and destroying it

Even recourse to tradition could bring about avant-garde attitudes before 1900. Ferdinand Hodler (1853 – 1918) is a revealing example. In his self-portrait of around 1881 (ill. p. 23) he chose a position created in the early 16th century, showing him sitting, his head turned over his shoulder, his face distorted into a "grimasse à la mode rembrandtesque" and he amalgamates both into the attitude of "rage". Sharon L. Hirsh commented more than 100 years later on this anger that challenges the audience: "When Hodler painted the picture, he really was in a rage. Recently returned from a one-year visit to Madrid and completely impoverished, he had to live in a disused watch factory, while he dreamed about great triumphs over those who looked down on his work. In the self-portrait he looks up angrily, as if he had been disturbed while reading something important; this may have been his reply to particularly harsh criticism of his paintings on exhibition." This exactly describes the avant-gardist's typical mental state. It is that of an artist who is deeply hurt because he is misunderstood. And not just the critic, this potential arch-enemy of all creative elites,

stands for the misunderstanding general public, but especially also the society of philistines and the petty-bourgeois. It was particularly this group the avant-garde fought against.

The term "avant-garde" comes from the military domain; it means vanguard, referring to daring deployment on the front lines. In a broader sense it also means any pioneering efforts for the usually radical implementation of social and cultural ideals.

The term then takes on a negative interpretation from a cultural-psychological perspective. According to that definition it refers to the heightened awareness of outsiders who suffer from the fact that the society for which they are fighting does not or not yet appreciate such risky, self-sacrificing commitment. Consequently vulnerability, irony and sometimes obsessive self-imposed isolation are amongst the characteristics of modern artists.

The term "myth" consequently takes on a new relevance. For the physical-mental state of the "pioneer" firstly wants stability in justification through mythical examples (divine right, creative aristocracy, the self-sacrificing hero). Secondly the myth comes alive inasmuch as it provides the projection-screen for the public's fantasies. The public

1839 — The French state buys the rights to the process developed by Niepce and Daguerre, the birth of photography

1850 — "Deutsches Kunstblatt" is published **1851 — The Great Exhibition in London (first world expo)**

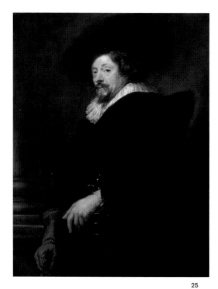

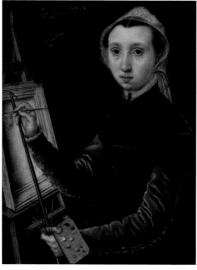

25 26

needs what at the same time it is allowed to be suspicious of: the vision of the "individual" who is different from "oneself"; but for that this individual also has to suffer!

Vincent van Gogh (1853–1890), with his life and suffering, is considered by us today as the prime example of the bohemian avant-garde painter. His last self-portrait of 1889 provides us with many signs crying out for interpretation (ill. p. 23). With heated brush-stroke patterns, the figure and the background are contrasted with, and integrated into, one another in light colours. The sitter is what his painting style shows: the personification of nervous restlessness enmeshed in fate. The penetrating stare and the rust-red beard dominate the blazing surface with powerful accents. The man staring at us from the sea of flames is a strange character consumed by yearning, desperately searching for the sunny side of art and of life, who strayed through France's countryside and towns, had hardly any success, mutilated himself and in the end, afflicted by insanity, took his own life. Vincent van Gogh and Paul Gauguin inaugurate the series of modern outcasts who continue to show us to the present day the existential extreme of exceptionally gifted, but traumatized artistic heroes.

Edvard Munch (1863–1944) is also on this list of outsiders. His *Self-portrait with Wine Bottle* (ill. p. 20) depicts him as a loner. The space closing in around him corresponds to his mental compulsions.

Lovis Corinth (1858–1925), like Hodler, took up traditions when he was out to prove his pioneer mission. For that reason he confronted himself and us in his self-portrait of 1896 with a skeleton (ill. p. 22). Corinth used the old *memento mori* symbol, putting his contemplation of his death on show, yet apparently also distancing himself from it.

Different again is Paula Modersohn-Becker (1876–1907). She conceived her view of herself (ill. p. 19) without any attributes to provide a commentary, unless we would see a fitting clue in her nakedness and her gesture embracing her "fertile" body. If we can speak of mythicization here at all, then because of the surrender to elemental naturalness. The artist is a producer of art and the bearer of a child. Consequently the naked woman's body demands dignified objectivity. In 1907, a year after she painted the picture, the young artist was dead. A friend of hers, Rainer Maria Rilke, said in his poem *Requiem for a Friend:* "In the end you saw yourself as a fruit, / you took yourself out of your clothes, brought / yourself in front of the mirror, you let

1867 — School of the Verein der Künstlerinnen und Kunstfreundinnen (women-artists association) is founded in Berlin
1887 — Fin de siècle artist's villa, the Lenbach-Haus in Munich

25. PETER PAUL RUBENS

<u>Self-portrait with Column</u>
c. 1637/38, oil on canvas,
110 x 85 cm
Vienna, Kunsthistorisches Museum,
Gemäldegalerie

26. CATHARINA VAN HEMESSEN

<u>Self-portrait at the Easel</u>
1548, resin tempera on wood, 32 x 25 cm
Basel, Kunstmuseum

27. MAX ERNST

<u>Au Rendez-vous des amis</u>
1922, oil on canvas, 129.5 x 193 cm
Cologne, Museum Ludwig

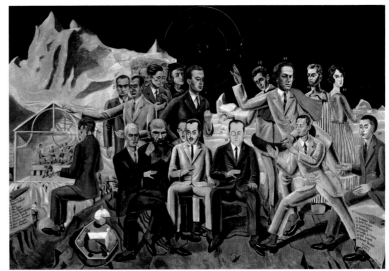

27

yourself in apart from your gaze; that stayed big outside / and did not say: I am that; no: this is."

Individualism inevitably moves in paradoxes. The individual, in order to be an individual, has to rebel against myths just as much as he or she has to put them forth anew. This was not changed by the fact that the generation of artists born around 1900 split into polar opposites around 1920. On the one hand were the fanatical proponents of a technocratic and political modernity, on the other hand there were also those who were passionately seeking and constructing the spiritual life. Both were modernistic and hungry for myths.

When Max Ernst (1891–1976) painted his *Au Rendez-vous des amis* in 1922 (ill. p. 25), he had both options come together in a "surreal" way. He moved the meeting to icy-clear mountainous heights, high enough above the lowlands of normality. Agitators of the unconscious sit peacefully next to dreamers of the cold spirit of the machine, albeit looking like dolls and lost in themselves, in any case carefully numbered. Next to the brothers-in-arms Breton, Éluard, de Chirico and Crevel (to name just a few), Max Ernst painted himself on the left (no. 4) sitting on Dostoyevsky's lap. The painting's message: everyone

who knows how to feel, think and design in a lonely, bold and hallucinating manner is welcome at this summit meeting of remarkables.

20th-century art lives not least from the distortions of its reflections, which are soon to be the origin of myths and insights. After Picasso and Beckmann, Francis Bacon (1909–1992) probably put this into effect the most grippingly. For his figures he chose poses and situations where he threw inner tensions convulsively to the outside and finally "shackled" them in coolly measured fields of colour and ghostly spatial cages (ill. p. 18, 85). Bizarre and blurred photographic snapshots served as the basis to this end. Again and again Bacon also tested this on his own person. Thus he proved that psyche and myth could still be reconciled, albeit fragilely, at the end of the 20th century.

Artists are "model-actors", it is true to this day and will remain true in the future. At the same time the validity of elitist positions is challenged everywhere. These days everyone can easily produce pictures of themselves with a digital camera. To a certain degree everyone can be an inventor and stager of their own appearance: a self-portraitist in other words. That in itself is not art. Thus in the end we long to have back the standards of art.

1902 — Women are permitted for the first time to study at an Art Academy
(Königsberg, Weimar)

Moses and the Burning Bush

Glass painting, 52.5 x 50.5 cm (without palmette border)
Münster, Westfälisches Landesmuseum für Kunst und Kulturgeschichte

The pane with the self-portrait of Gerlachus is one of the most important examples of medieval glass painting in Germany. Master Gerlachus, with brush and paint-pot in his hands, bearded, is presumably a layman in the service of the monastery. He created the whole of the multi-part pictorial programme that extends across the five windows that were once in the West choir of the monastery church in Arnstein on the Lahn. Only five of the original 15 panes are still extant.

Here, in the lowest pane of one of the windows, he has claimed one field of the picture for himself. It has a round arch and is fitted in such a way that it repeats on a small scale the shape of the window itself. The framing yellow inscription provides for both demarcation and integration. Gerlachus asks for God's mercy. Demonstratively, he places his brush on that place in the frame with the inscription which is already complete apart from the letter "M". Thus the brush is doing three things. While he "writes" the supplication, he points to the wording and also points to himself as the instrument by which all the coloured glass is decorated with black outlines and shadings, in other words is being "painted" and "drawn". Practical artistic work and spiritual services are demonstratively united here, both of them with personal reference to the one who is supplicating, praying and working.

What graphic event is the glass-painter assigning himself to? What is his superordinate theme? The motif is *Moses and the Burning Bush* with the appearance of God, as recorded in Exodus 3: 2–4. In his left hand Moses is holding the staff which God transformed into a serpent and back into a staff; in front of him he has placed his shoes, which he has taken off at God's bidding.

The heads of Moses and God are, apart from the differences in their haloes, much the same. The medieval beholder knew in any case that physical likeness was not important here, particularly as the Old Testament text refers to God's presence as only a "voice" in the flames, and not as a visible bodily apparition. Matching figures to external nature was not a criterion for medieval art, least of all in respect of individual comparisons. What was important was the significance of the type. Moses and the divine voice exist here simply as signs represented in human form.

All that counted was to see and to know that man was made in God's image, and in that sense only a spiritual likeness. For the people of the mid 12th century, it would have been a meaningless question whether Gerlachus, in the delimited field with the round arch, was seeking to preserve his individual celebrity for posterity. For it was not the figure, but rather, as it were, the self-writing name that wished to be preserved in the memory, insofar as it had representative value. He wanted and was permitted, through reference to himself, to ask for God's mercy for all those praying to God in this church. (Scholars even presumed for a while that Gerlachus was not just the painter of this window, but had also endowed it.) Where a visible and creative act in this sense had been performed, it could at the same time pictorially represent the attitude of others. But however the balance between individual and community was struck, however it was understood: devotion to God and supplication for mercy appear in industrious and artistic activity. Prayer and work come together.

REX REGU(M) CLARE GERLACHO PROP(I)CIARE

King of kings, show thyself merciful to Gerlachus

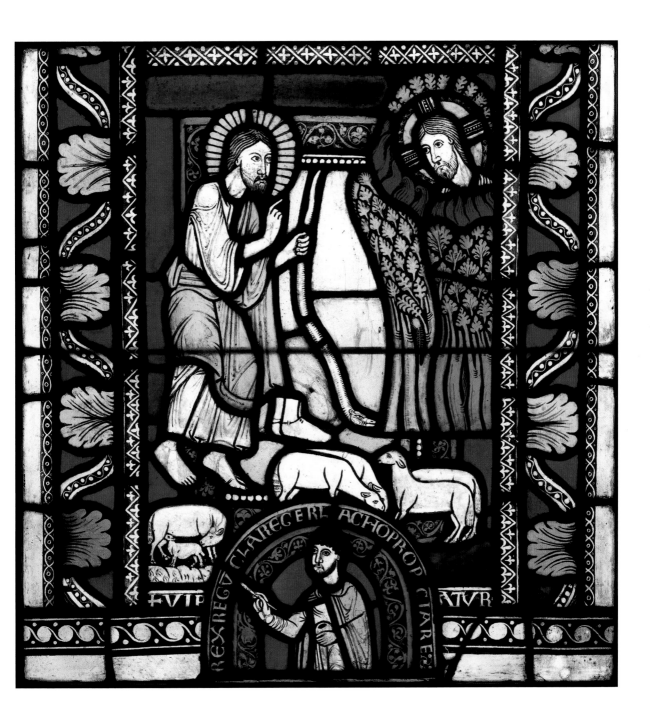

coronation of the virgin

Detail, resin tempera on panel, 200 x 287 cm
Florence, Galleria degli Uffizi

When can European artists in their self-depictions dare to contravene the injunctions of propriety? Tellingly, it did not wait to happen in autonomous self-portraits, but already in what are known as *in assistenza* portraits, in other words a composition in which the painter "conceals" his own figure in the painting, in order, from a more or less secret place, but often all the more effectively for that, to look out at the beholder.

An early and remarkable example of this can be seen in Fra Filippo Lippi's work. Between 1441 and 1447, this Carmelite painter-friar depicted himself *in assistenza* on the retable of the high altar in the Benedictine church of San Ambrogio in Florence. In the left foreground of this large painting, which depicts the Coronation of the Virgin, he has mingled with the praying onlookers: a little hidden, it is true, behind a pious character at the lower edge, but once you have discovered him, his pose is quite striking. His gaze is turned away from the central event and, almost challengingly self-assured, directed towards the beholder. His chin resting on his hand, he kneels there on the margins of this heavenly coronation scene.

The fact that he is not looking at Mary and God the Father in the all-dominating focus and centre of the picture, nor actually at us, but rather at the capriciously contemplative appearance of himself, that is altogether unusual. "Consciously disturbing the devotional relationship between the beholder and the Mother of God, the artist draws attention to himself," was how Sigmar Holsten (1978)

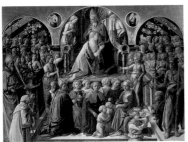

Coronation of the Virgin, c. 1445

judged this kind of self-staging. And when one considers that the sources report on certain scandalous circumstances in the life of Fra Filippo, one will at first agree with this judgement. One can read that the friar transgressed all boundaries in his self-assured urge for freedom. More than once, it is said, his relationship with the nun Lucrezia Buti clashed with his vows. On the other hand, because he was one of the most inventive and technically skilful painters of the Florentine Renaissance, he could, it is said, always be sure of being paid well by his ecclesiastical clients. His superiors in the order and patricians alike evidently turned a blind eye to the human weaknesses of such an outstandingly talented friar.

But a different interpretation seems possible. Provocatively worldly and cheeky as the errant gaze of the painter may seem at first sight, with his head resting on his hand, a breach of propriety is not a necessary conclusion to draw. Supposing it were the new, aspiring intellectuality of the increasingly self-assured Renaissance artist that was being expressed? The gesture of the creatively inspired? If someone could use perspective construction, poetic colour and inventive figuration to compose the whole of heaven in his head, should his productive forces not also be allowed to fill old devotional poses with new, worldly intensity? And indeed, traits of intellectual tension and dreaminess can be read in Lippi's pensiveness. The most beautiful images of heaven, the interpretation would then be, are seen in the mind's eye of creative individuals. In any case, heaven cannot be encompassed by ordinary vision. The painter-genius has heaven and earth within him.

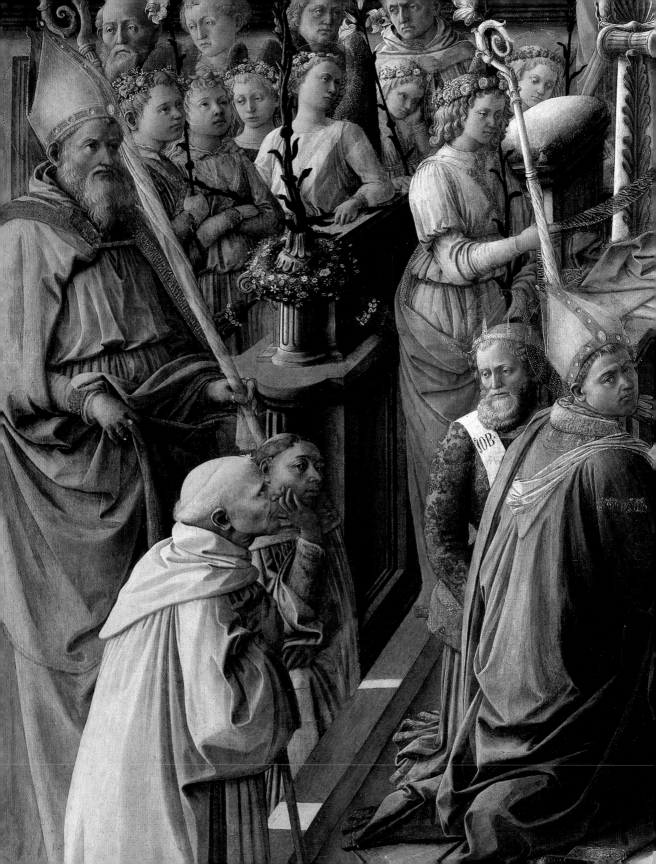

self-portrait

Oil on panel, 67 x 49 cm
Munich, Bayerische Staatsgemäldesammlungen, Alte Pinakothek

No artist's self-portrait in the art of the early modern period addresses us more solemnly, more portentously, than Dürer's life-size image painted in 1500. No other work unites so demonstratively proudly, and at the same time so modestly, all the maxims of piety and artistic reflexion that held sway as the 15th century passed into the 16th.

The very inscription, monogram and date, written in golden Antiqua to the left and right of the head at the level of the eyes of the frontally composed face contain a humanistic-Christian self-declaration: "Albertus Durerus noricus / ipsum me propriis sic effin / gebam coloribus aetatis / anno XXVIII" (I, Albrecht Dürer of Nuremberg, painted myself in colours appropriate to me in the 28th year of my age.) As the modern replaced the medieval, a painter made himself the model of the human being, the artist, and nearness to God. What has struck every art lover and expert over the centuries in this sensational work, its decisive, even now confusing stroke of genius, is the transformation of the artist's own appearance as seen in the mirror into the idealized image of Jesus Christ.

Against a dark background there stands out, austerely symmetrical, the half-length figure of the painter, beard carefully trimmed, moustache exuberantly flowing, long locks exquisitely arranged. He is wearing his Sunday best. In his right hand, which he presents conspicuously at the bottom edge of the painting, he is holding together the fur-trimmed revers of his coat in front of his chest, at the same time forming his fingers into

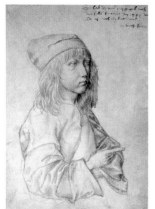

Self-portrait as 13-year-old, 1484

a gesture that comes across as rhetorical. Everything in this self-presentation is ordered and measured, everything is sculptural nearness. The limpidity of the overview corresponds to a marvel of detailed surfaces (pores, wrinkles, curls). The facial features, which the painter has very slightly idealized, are impassive and serious: it has been centred, in other words the axis of the nose is also the vertical axis of the picture, which for its part reflects the "golden section" in many of its horizontal and vertical proportions. The imaginary line joining the eyes, which can be extended to form a horizontal axis passing through the inscription, becomes the unit of measurement of a module by which the figure and the area of the picture become geometrically commensurate. The oval of the face, the triangles of the hair, the plinth of the bust, the angle of the collar, come together to form a composition whose basic design principle is that of the Byzantine icon. By applying this sacred formula to his own physical appearance, Dürer is claiming the highest standards of idealization for himself and his art. Gazing calmly at the beholder, he seems to be saying: "I am made in the image of God, and not just in one way but in several: as a human being in the sense of the creation story, as a citizen of Nuremberg in the sense of the commandments of a Christian life, as a famous artist, who seeks to place the skill of future painters on a new foundation of insight and knowledge."

With this many-layered work, Dürer concluded a series of self-reflexions begun while he was still a child. Already in 1484, still only 13, he had portrayed himself "from a looking-glass" and thus put his name on the earliest drawing of a child in the history of art. The culmination of this series, the panel painted in 1500, remained throughout his life as a private admonition in his studio, not least, presumably, because it might too easily be misunderstood. It was intended to be seen (preferably only by fellow-artists at first) as the personified utopia of Christian artistic humanity.

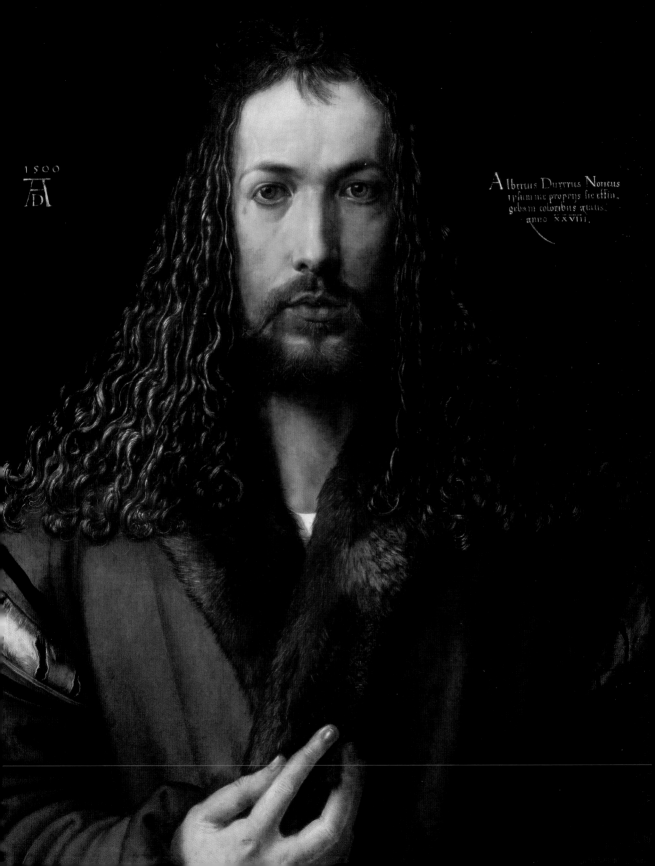

1500

Albertus Durrerus Noricus
ipsum me proprijs sic effin
gebam coloribus aetatis
anno XXVIII.

self-portrait as David

Oil on canvas, 52 x 43 cm (cropped)
Brunswick, Herzog Anton Ulrich-Museum

The still youthful man is wearing his hair shoulder-length. His chin is raised in truculent manner, his mouth energetically shut. We are met by a melancholy gaze emanating from softly shadowed eye-orbits and lightly reddened lids, its intensity stressed by the wrinkles of rage above the root of the nose. While the man's gaze is challenging, he turns his right shoulder towards us. Intensity and dismissive pride create thus a tense contradiction. Also under tension are the physicality and the illumination. Predominantly dark, the space into which hair, throat and chest disappear almost uncontoured does include a few bright spots, but these are very specific: the emotional focus of the duskily modelled face and, above the transitional beige and green of the garment, a brightly shining piece of metal on the shoulder. This man, then, is wearing martial armour. He is, as we have known since Giorgio Vasari's mid-16th-century artist biographies, none other than the painter of the picture himself. Giorgio da Castelfranco, known as Giorgione, has a prominent place in the artistic history of Venice, where he worked. Although there is little archive material to tell us much about him personally, he must, like Dürer, be seen as one of the most important innovators on the threshold of the modern age.

With his musically inspired, often mysterious painting, he built a bridge, it is said, between the older art of the Bellini workshop and that of the young Titian. From Leonardo's pictures, he had, it is said, learned a vibrant coloration of the painterly form *(sfumato)* which he creatively developed, and in addition, he is supposed to have been cultured, with an interest in music and poetry. Thus the tension-charged characteristics of this late self-depiction (he died of the plague soon after) certainly fit the ambition which the sources suggest.

Occasionally the pictures themselves are the best sources, even when they have not survived the years intact, as with the painting in Brunswick, which has been cropped. Important parts which illuminate the mystery of the portrait character have been lost. However the original version can be reconstructed thanks to an etching by Wenzel Hollar dating from 1650, when Giorgione's picture was still entire. These additional components explain the strange mixture of pride and melancholy.

Originally, the sitter was holding the severed head of Goliath out in front of him on the balustrade that framed the picture at the bottom, adopted in other words the role of the biblical hero David. Giorgione disguised himself in a dual heroic role. In the virtuous hero David, he saw an altogether theatrical "image" which could be translated into the new ideal image of the virtuoso painter. But because painters are the new divinely inspired spiritual heroes, because they for this reason have to suffer from attacks of the artists' disease of melancholy (see our other examples: Lippi, Rosa, Poussin), we have this so strangely mixed facial expression. This explains the urge for disguise, mise-en-scène, self-enhancement. Giorgione's *Self-portrait as David* is the first allegorical artist self-portrait in the history of European art.

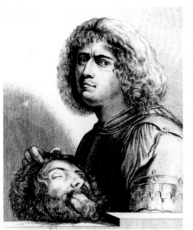

Wenzel Hollar, Self-portrait of Giorgione, 1650

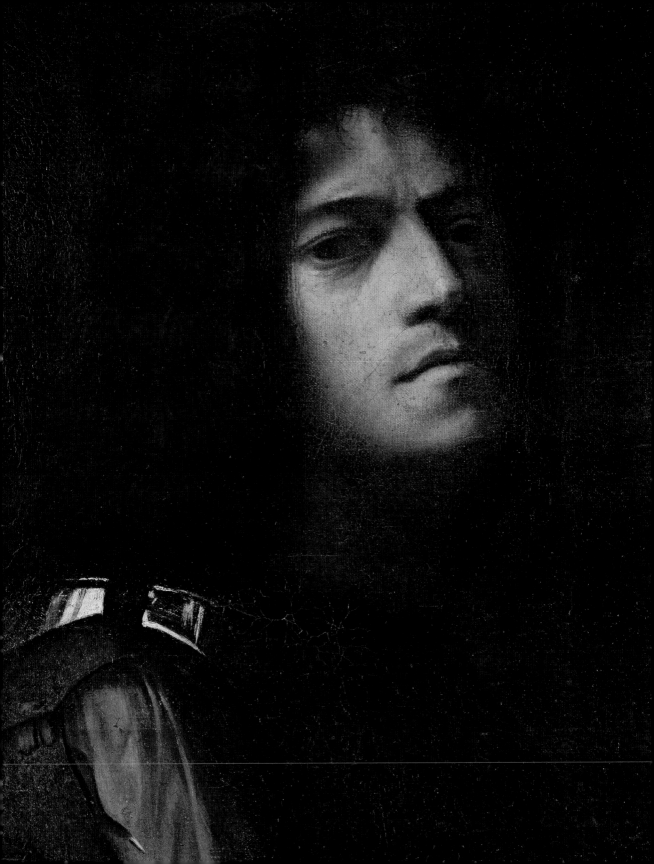

self-portrait in convex mirror

Oil on spherical wooden calotte, diameter 24.4 cm
Vienna, Kunsthistorisches Museum, Gemäldegalerie

The story of the self-portrait genre had been in full flower since the early 16th century. All the philosophical and artistic principles of likeness-creation, role-play and prestige-display had by now their premieres already behind them, or else were in the process of establishing their promising formulae. The artist self-portrait could now even afford certain additional elements of reflection, in the case of Parmigianino's *Self-portrait in Convex Mirror* quite literally.

The young painting genius Francesco Mazzola from Parma, whom we know as "Parmigianino", used his self-portrait, which dates from 1523/24, to create a *trompe l'œil.* The very fact that he did not paint himself directly, but captured rather the fleeting and distorted image in a round glass as an oil-painting on a similarly rounded wooden surface, was a stroke of genius. This is a "Mannerist" diversion which sensitizes the beholder to the reality of painting, which is inventive while at the same time holding up a seeming mirror-image likeness of the world. Although Parmigianino was able to present such a dual demonstration in all its novel extent as a creation of his own, there was a tradition behind it. Pinturicchio (see ill. p. 15) had, similarly, used his own image to reflect on the medium a good 20 years earlier, albeit in a less elaborate version. Both self-portraits show that they somehow "know" about their illusory aspect. Parmigianino, whom the sources describe as angelically beautiful and in love with the art of his Roman role-model Raphael, is doing everything he can here in order to present himself as one who knows, as a virtuoso master of painting as a medium of enlightenment, as the new, more modern Raphael. At the edges of the spherical picture, he so-to-speak zooms the spatial elements of his co-reflected studio to the round frame, while the tender face with its vigilant eyes is centrally focused, in other words largely undistorted. At the bottom, in the foreground, we see the much enlarged pale hand of the artist. In its fingers, which are elongated by the distorting effect of the mirror, but nonetheless elegantly curved, is a drawing implement (pencil, wooden rod?). Horny-handed sons of toil do not have fingers like this; this is the hand not of a craftsman, but projecting from a fashionably ruffled sleeve, that of an "intellectual" virtuoso.

Painting advertises its intellectual control, and this can become manifest precisely in distortion. Over the whole scene lies a tender shimmer of cool, pale colour. Not only the contours, but also the colours seamlessly change their clarity in the reflection. Thus the artist himself, and even more so his painting, are made the model for precisely observed and "reflected" effects. The distorting mirror becomes a roundabout way to the truth: painting is nothing but illusion, but the most beautiful illusion there is, and more durable than the natural reflection which appears when you look, only to disappear when you look away. Rudolf Preimesberger (2005) is quite right to call this doubly reflective artist self-portrait by Parmigianino a "synthetic" picture, "whose unnaturalness and artificiality remain to be emphasized". When the young painter presented it to Pope Clement VII in 1524, he may well have guessed that he was presenting him with a piece of art history.

Self-portrait (?), c. 1520

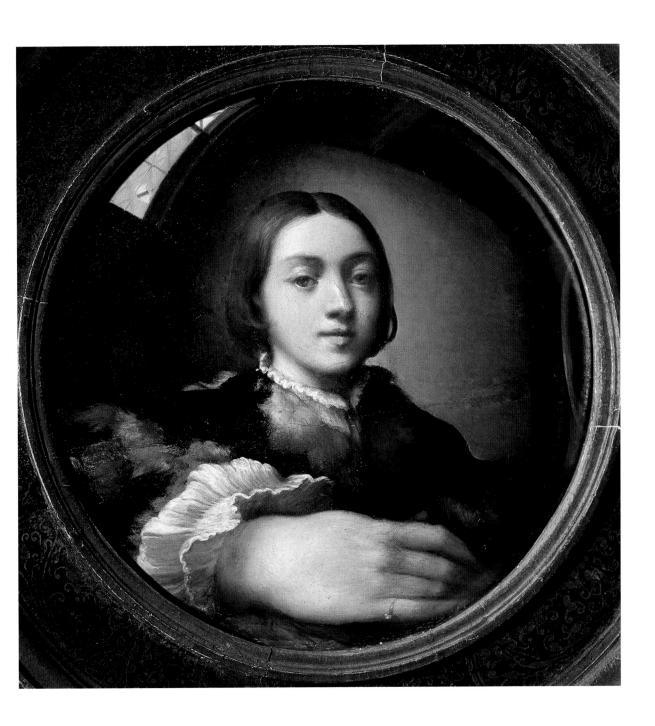

self-portrait on the skin of st вartholomew

Detail from the "Last Judgement", fresco
Rome, Vatican, Sistine Chapel

In the person of Michelangelo Buonarroti the first genius, or in modern terms, the first artist cult-figure, stepped on to the stage of art history. Fêted by popes and princes, discussed by disputing *literati,* adored by fellow artists, misunderstood and feared, the great sculptor and painter was a legend in his own lifetime. But he never painted a self-portrait as such. Those pictures which in all probability depict himself exist only as "concealed" self-portrayals. And in these, what is expressed is always an attitude of self-doubt.

In the middle of the *Last Judgement* fresco on the altar wall of the Sistine Chapel, to the right beneath Christ the Judge, our eye is drawn to the place where the apostle and martyr St Bartholomew is displaying his attributes. In his right hand he is holding the knife with which, as legend had it, he was skinned alive; in his left, he is holding the skin itself, including that of the face, with its tortured folds and demonic hollows. Beholders have always noted the particular similarity of this tattered facial bladder with the famous gnarled and melancholic face of the artist. This dark countenance of the *divino artista* was known from paintings by fellow artists, and in at least one case from a sculpture by Michelangelo himself. In the Pietà in Florence, the figure of Nicodemus, who is holding the body of Jesus, just taken down from the Cross, close to his breast in sorrow, is probably also a hidden self-portrait. And it has also always struck beholders that the flayed face in the *Last Judgement* bears no resemblance to the face of the saint sitting on his cloud. Instead, the apostle

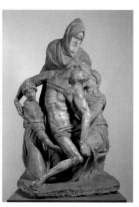

Florentine Pietà, 1547/55

evinces a fateful and unmistakable similarity with Michelangelo's notorious contemporary Pietro Aretino. Those among the fresco's beholders who recognized this at the time would certainly have heard too of the private feud between the moody giant of art and the intriguing head of the *literati*. Gossip and legend belong together!

It was only some 400 years later, in about 1920, that the various tracks of Michelangelo research met in interpretations that plausibly linked art and life. In this view, Michelangelo painted himself into the martyr's skin in order to indicate the wretched nature of his existence. To feel powerless in the face of the world's narrow-minded view of art, and maybe exposed to a merciless judgement on the part of God to boot, that would have been entirely in the spirit of the tragic self-martyrdom which can be inherent in the cleft between self-aggrandizement and self-deprecation. On the other hand it was people like Aretino who always got on the nerves of the thin-skinned Michelangelo. And not least, flaying is a known symbol of renewal and rebirth. Hope of earthly fame and a redeemed life in heaven is the positive interpretation of the flayed skin. Only through genius and faith, but only ever symbolically, can one get out of one's skin. When it succeeds, scope opens up for fantasy. Space also for defence and attack. In this way, Michelangelo "plays" with his fate in the midst of the Last Judgement. It is the played-out concept of art as painful work. As the power that the artist genius shares with the Creator, because it was by Him that it was bestowed.

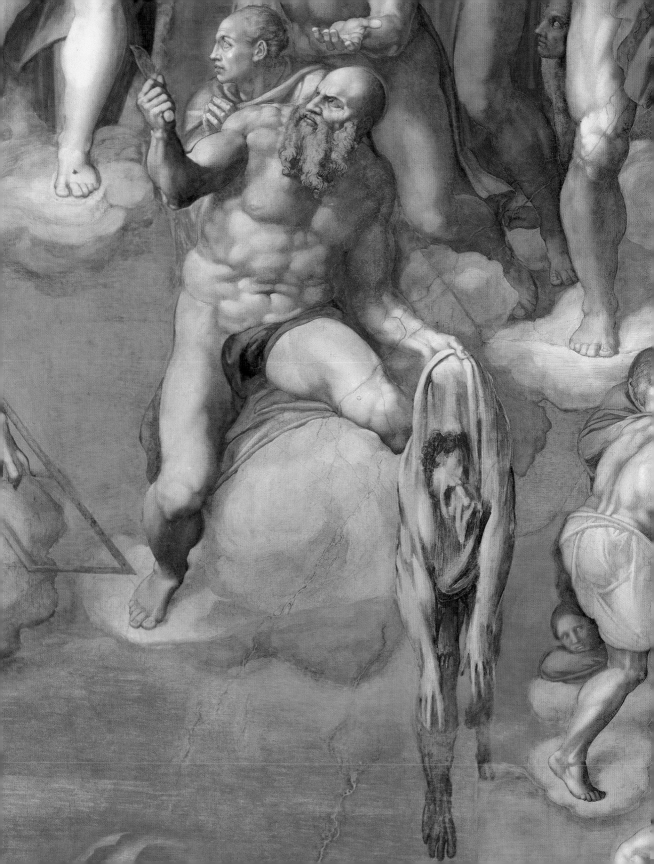

David with the Head of Goliath

Oil on canvas, 125 x 101 cm
Rome, Galleria Borghese

The scandal-ridden Italian painter of the early Baroque, Michelangelo Merisi da Caravaggio, did not, unlike Giorgione, identify with the heroic role of David. His interest, drastically self-deprecating and in this sense comparable to Michelangelo's face on the flayed skin in the Sistine fresco (see ill. p. 37), lay in the severed head of the monstrous debauchee Goliath. And in order to make the total baseness, but also the wretchedness, of the giant visible, his head is grasped by a tuft of hair and held in the very forefront of the picture.

It is with corresponding abruptness, then, that this face jumps out at us from the picture, a face that we can reliably recognize, in its normal version, from a number of other pictures. The painter has therefore uglified his own features: we have a mask marked by hate and suffering, frozen in death. The eyes are broken, the rumpled brow marked by the fatal wound, the mouth still open from the cry of agony, the teeth broken and bleeding. The sallow pallor of death is clearly distinguished from the youthful flesh colour of the victor, David. He in turn embodies the other world of the good, the beautiful, of what is pleasing to God. But David is not just the pretty young victor who lets his sword drop after completing the act of beheading, he seems for a few moments to want to show sympathy for his victim. In his youthful features, darkened by anger, there is a note of sadness for the necessity of the bloody deed. The elegiacally inclined head recalls, as with Giorgione (see ill. p. 33), the poetic inspirational force of David the psalmist. Admittedly, given that here David's arm is stretched abruptly forwards and parallel to the blade of the sword, it is ultimately the heroic character of the hero which sets the tone.

All the elements together, figures and characters, are enclosed in that darkness which was "usual" for Caravaggio, as Bellori drily noted in 1672. It is at first sight a naturalistic nocturnal darkness, but on closer inspection it reveals its overwhelmingly artificial nature, calculatedly mysterious and exaggerated. Lighting in Caravaggio often has an aggressively revealing function, and this picture is no exception. Fragmentation and surprising recombination are further typical stylistic devices, and in this self-portrait as Goliath they confirm their astounding modernity.

But why all the negativity, why the deprecation of his own self into the base and ugly? Supposing for a moment that self-portraits were ultimately intended to put across positive messages, what would the positive intention in this bizarre depiction be? We cannot be certain. Possibly, in the last phase of a life disfigured by scandal and crime, Caravaggio was taking stock, maybe this was even meant as a public apology. His personal vice, his inventive artistic "shamelessness", his murderous temper (he had after all been prosecuted for homicide in 1606), but also his genius as an artist – all of this could certainly have been the motive for a complex self-explanation. His pictorial programme could have been determined by a number of intentions: Christian morality teaches that only those who "abhor (themselves) and repent in dust and ashes" (Job 42: 6) will attain their due elevation. And only those who acknowledge ugliness have understood the condition for beauty. Or to put it another way: he who knows how to take on ugliness as a role has proved his freedom.

"…the other half-length figure of David holding by its hair the head of Goliath, which is his own portrait, he represented by a youth with bared shoulder, his sword in his hand, the background and shadow in very strong colours, as was usual with him in order to give force to his compositions and figures…"
Giovanni Pietro Bellori, 1672

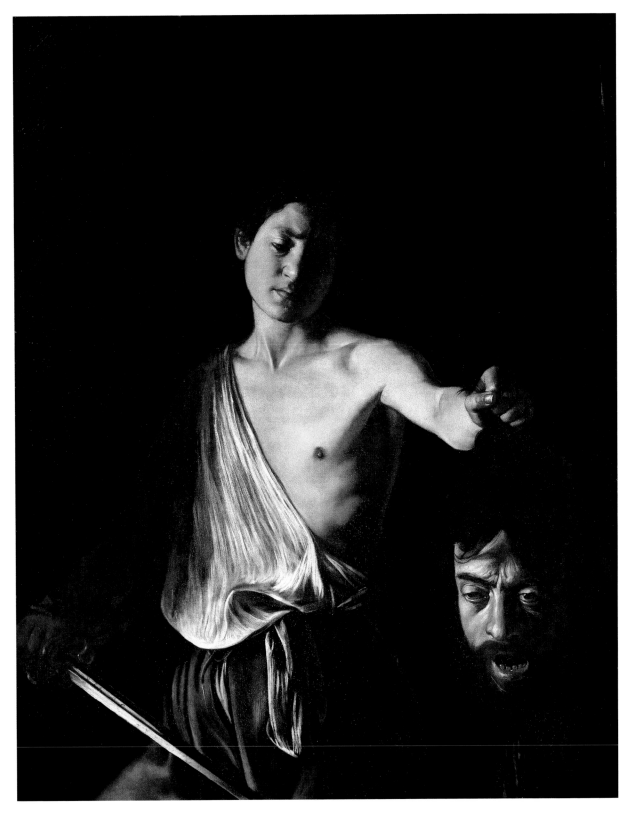

Rubens with Isabella Brant in the Honeysuckle Bower

Oil on canvas (mounted on wood), 178 x 136.5 cm
Munich, Bayerische Staatsgemäldesammlungen, Alte Pinakothek

Rubens is the first example of the "artist prince", who claims the attributes of his genius and divinity not only in theory, but in the form of career privileges, or even of the power afforded by political office. After 1600, artists, as manufacturers and merchants, were able to hold down posts as academy directors, embassy attachés and councillors. Assuming business success, individual artists could, if they pursued an appropriate marriage policy, achieve princely status. Rubens is the first comprehensive example. After an apprenticeship spent travelling through Italy and Spain, he returned in 1608 to Antwerp, where the following year he became court painter to the Spanish governor and his consort, married Isabella Brant, the daughter of a patrician family, and a year later acquired the piece of land "am Wapper". Here he resolutely pursued the construction of a palace-like seat with the appropriate display features, as well as the further expansion of his painting and engraving workshops. In the intervals between all this, he was sent on diplomatic missions to England and Spain. It is only against the background of such a distinguished multiple career that we can understand the complex programme of the *Honeysuckle Bower* in Munich's Alte Pinakothek.

About 32 years old, Rubens here presents himself together with his young wife Isabella in the accoutrements of chivalric elegance and in a state of happiness resulting from new love. The pair have sat down in the shade of a honeysuckle bower as if after a brief stroll, and are visibly enjoying the beauties of their metaphoric and natural "situation". He, now the *grand seigneur,* sitting with his legs crossed on a balustrade, is supporting with his right hand the hand of his wife, who is seated beside him on a grassy bank a little lower down. Each inclines slightly towards the other. She, while somewhat lower in the composition, is in no way his inferior in social rank, and lovingly takes his hand, casting a calm and friendly glance at the beholder. Ruff, Florentine hat, and brocade bodice casually emphasize, in combination

with the angle of her head and the seated motif, the slight tension in the compositional bow which is further reinforced by her relaxed left arm and the fan she is holding in her left hand. This bow finds its response in her husband's bodily attitude, the position of his arm, and the gestures of his hands, while his orange hose leads a whimsical life of its own alongside her wine-red skirt.

Rubens is portrayed looking over the beholder from high above, his facial expression is calm and contemplative, but in no sense so blasé as a modern museum-goer might at first assume. In other portraits too, we encounter this decidedly restrained gaze of a man whose humanistic culture was solid and, in particular, based on the ideals of Stoic inner calm. Enjoyment of life in the spirit of self-control and self-confidence, that is the philosophical message of this gaze. Both man and wife are visibly aware of what they have in each other, how precious their life together is, both as solemn matrimony and as natural romantic bliss. Everything around them is green and flourishing. At the bottom left, our own gaze is drawn into an extensive landscape. Following in the motif tradition of the "garden of love", Rubens in this picture summarizes his individual, family and artistic bliss.

> "… she was not fickle and had no feminine weaknesses, only kindness and tenderness, and on account of her virtues was loved by all during her life and mourned by all after her death."
>
> Peter Paul Rubens, 1626

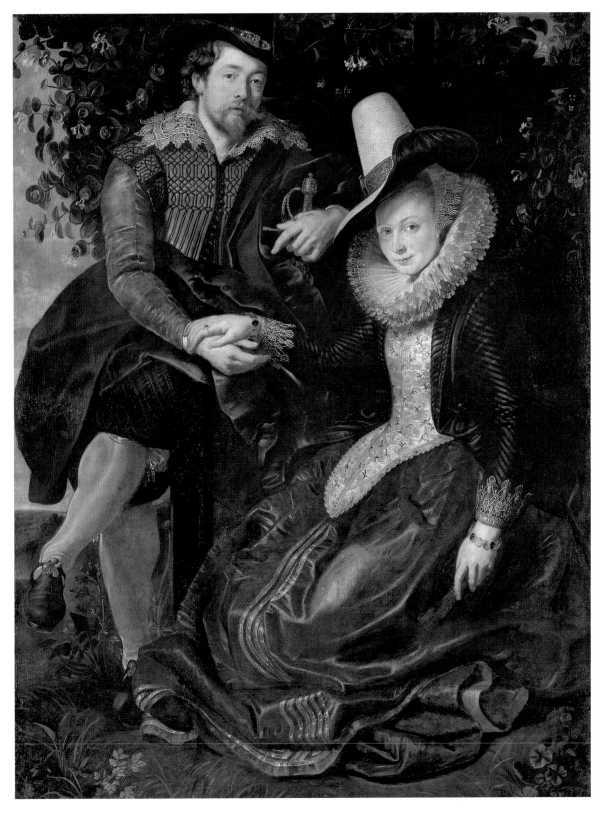

self-portrait as philosopher of silence

Oil on canvas, 116.3 x 94 cm
London, The National Gallery

"If you said nothing, you'd still be a philosopher." This saying expresses not only an appreciation of silence and contempt for idle chat, but points in particular to the philosophical status of silence. What is praised in other words is not the dull silence of someone who has nothing to say, but rather thoughtful, perceptive, creative, knowledgeable silence. For art, the silence option has been important time and again ever since Antiquity. Thus the pictorial eloquence of poetry was compared with the silent poetry of painting with the intention of honouring different forms of expression and communication with a view to stressing their common, immanent power of persuasion.

Salvator Rosa, who was active predominantly in Rome and Florence, was one of the most versatile and idiosyncratic artists of the 17th century. He used – and also criticized – every linguistic means for this appeal. A painter, engraver, poet, actor and musician in one, in about 1662 he composed for himself a telling graphic monument. Surrounded by the figures of Painting, Philosophy and satirical Caprice, he fêted himself as one who could, from all the means of inspiration, seize on, and bring out, the right one for the moment. No less spectacular is his painted self-portrait dating from c. 1641. As Kristine Patz was able to show convincingly in 1998 and 2005, Rosa here, in his own person, embodies the power of melancholy clear-sightedness from the spirit of scepticism.

Standing out against a sky whose colours are threatening, we see the dark silhouette of a three-quarter-length figure in a reddish-brown coat, holding in his right hand a tablet with an inscription. This inscription is a message urging us to keep silent, unless we really and truly have something to say which is better than silence. This challenging maxim, which Rosa had borrowed from classical aphorisms, is matched by a head inclined in melancholy fashion to one side, the eyes staring at the beholder with a penetrating gaze from beneath a black cap. Because the face with the energetically tight lips is only illuminated from one side, in the expression of the surly man is reflected the depression which also keeps the tension between the figure and the light of the sky. The painter is, as we said, wrapped in a reddish-brown, or more precisely a rosewood-coloured coat fastened at the neck. And as if this fastening weren't enough, he has placed his left arm across his chest, so to speak bolting shut his own person.

Much in this figure is austere and aloof. But just as there are occasional targeted bright patches in the picture, the active counsel emanating from the figure, whom we see slightly from below, is unmistakable. Himself gruffly aiming at truth, and suffering as a result, through all the idle chatter of the world, he demands of the beholder the same courage to seek and tell the truth, the same contempt for all evasiveness and empty phrases. Only philosophy and the arts are capable of truth.

In this way, the figure and the picture as a whole become a proof of truth, a proof of themselves. For although canvas and paint develop their rhetoric only out of silence and it is precisely through motionlessness that the man wrapped in his philosopher's coat importunes us, at every moment this collected silence turns into speech and a loud motto. *Sub rosa,* in other words privately, the rose being among other things a symbol of silence, Rosa has spoken. Through his self-portrait, he has taken us to task.

Aut tace / Aut loquere meliora / silentio

Either be silent or say something better than silence

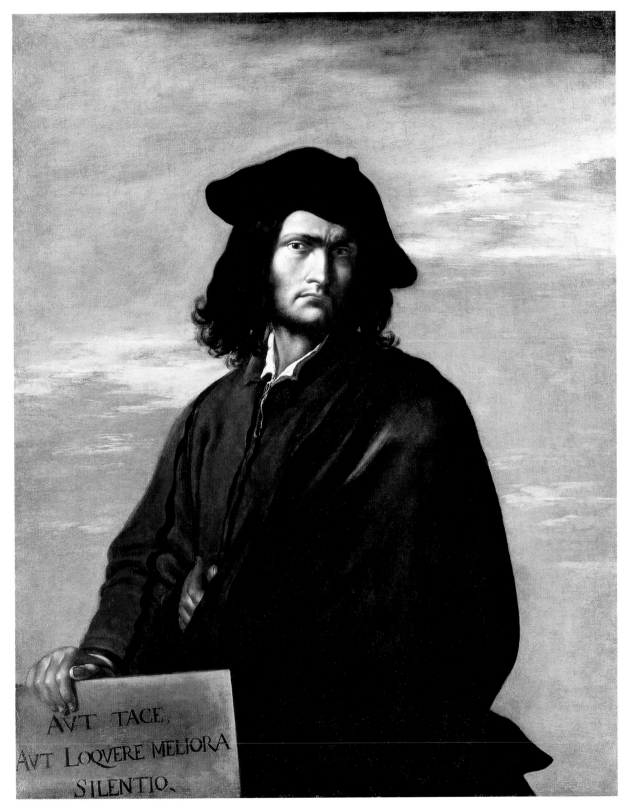

AVT TACE,
AVT LOQVERE MELIORA
SILENTIO.

self-portrait

Oil on canvas, 98 x 74 cm
Paris, Musée National du Louvre

Nicolas Poussin's art embodied the ideal of rule-governed order in the 17th century. The figure compositions were "classical", in other words balanced, not too crowded, and determined by the drawing. But even where light and colour dominate in the paintings, their sensuous characters are always strictly regulated. And where narrative ideas or parable-like allusions are required, they are reflected on imaginatively by the painter with his literary education. Poussin's self-portrait of 1650, commissioned by the artist's Parisian friend and patron Chantelou and painted in Rome, gathers together all these features in a well-calculated abundance. It was meant as a friendship picture, in which the painters ability, knowledge and sensibility were depicted in multiple facets, but at the same time in harmony. Personal tensions had to be worked through. For although Poussin had recovered from a serious illness, he was still sickly, and had to overcome both personal and professional crises. In these circumstances, it is not hard to find a psychological explanation for sceptical self-observation and disciplined hard work.

The 56-year-old painter is giving us a hard look. He has, like so many of his fellow-artists before and since, chosen the side-view, looking-over-the-shoulder pose. Its witty content has here a hint of the sceptical and melancholy. The face, illuminated from one side, shows wrinkles on the brow, reddened eyes, an energetic mouth. Poussin's right hand is resting on a drawing pad, a polished gemstone glittering from a ring on his finger. His black cloak recalls the dignity of philosophers' garments in classical times. The thick, beautiful curls are not his own, but only a wig.

The background, built up close behind the figure, and given some depth by the line of the red chair-back, consists of canvases which, in some cases already with their gilt frames, are leaning one behind another. The one in front is empty, containing only an inscription and shadow: room for thoughts as yet unpainted, perhaps unpaintable.

Thus the total surface of the picture has a grid-pattern, but thanks to the rhythmic staggering and overlapping, it is always full of tension, and never schematic. It is only through the generous interplay of angles and crosses that we become aware of the symmetry of the seated pose and of the arrangement of physical deviations. Thus for example the melancholy pair of eyes lies somewhat off-horizontal in the intermediate zone between two canvases. But it is precisely this near-horizontal which guides our gaze, directing it towards the only visible content within the arrangement of picture-frames, and is its key point to boot. Here, there can be seen the fragment of a beautifully clothed woman as a picture within a picture. On her head she is wearing a diadem set with an eye in front. She is smiling at someone outside the visible picture. Two arms are embracing her, likewise from outside.

Poussin's contemporary, the art-writer Giovanni Pietro Bellori, was able to interpret this fantasy-inspiring female apparition. It is in his view the personification of painting *(Pictura)* with the perspective eye above the natural eyes. She is being embraced by the love of art, *Amicitia,* which can always also refer to human friendship. At this place in the picture Poussin thus refers in detail to the dual friendship, which makes the painting both a personal and artistic manifesto.

Self-portrait drawing, c. 1630

EFFIGIES NICOLAI POVSSINI ANDEL
YENSIS PICTORIS ANNO ÆTATIS
ROMÆ ANNO IVBILEI
1650

self-portrait with vanity symbols

Oil on canvas, 89.5 x 122 cm
Leiden, Stedelijk Museum De Lakenhal

In many instances in the history of art, the claim of individual picture genres becomes so pressing that it can only be fulfilled by the combination of genre features. Self-portrait and still-life could, in this sense, hardly ever have been more excitingly united or more instructively related than in this self-portrait by the Leiden painter David Bailly. The very choice of landscape format makes it clear that it is not just the monument-like vertical of the person that counts, but that the broad depiction of significant things has equal status.

A painter is sitting in the corner of his studio at a table which is overloaded with decorative and art objects of all kinds. There are pictures hanging on the walls behind, while the swag of a curtain hangs down from the ceiling. If it were not for the fact that there is also a palette hanging on the wall, and if the painter were not also holding a maulstick, we wouldn't know that we were in a painter's overcrowded studio at all. Bailly – for it is he who is the painter at the table, the owner and user of all the objects, the one who is staging the parable in which they are the props – was in his day a successful painter of still-lifes. He is showing us his world, even though we cannot take in all the details and their secret associations immediately: the oval portrait of an elderly man, which is recommended to our particular attention beneath the painter's left hand, and next to it a portrait of a woman in the same manner, a recorder, a candlestick, tumblers, one standing, one lying, a knife, coins, nosegay, jewellery cases, wilted roses, small sculptures (maenad, St Sebastian), texts, bead necklaces, books, tobacco pipe, hourglass, and – unmistakable in the foreground – a skull.

These symbolic props are notable for their quantity and variety, and for the fact that they are gathered together "accidentally on purpose". Their elements are to be perceived while they are in the middle of being used, taken as it were out of the flow of time. Rapid transience competes with the gradual. Thus the standing glass is still almost full, smoke is rising from the candle, the sand in the hourglass is running, the roses were in bloom not long before. Three soap-bubbles are floating, tender and clear, above the other objects: in a moment they will have burst. But what has all this to do with the theme of self-portraiture, except for the fact that the painter wants to be shown as a still-life specialist?

The answer is: everything in this picture is evidence of self-revealing deception. The inscription on the paper hanging over the edge of the table reads accordingly: alongside the biblical *vanitas vanitatum* ("Vanity of vanities") is the signature of the painter and the date of the picture, 1651. At this time David Bailly was 67 years old. He cannot possibly, then, have been the young studio painter at the table. This young man may be looking thoughtfully at us, while pointing his maulstick down to the floor as if by chance, but is he a thinker admonishing vanity? The solution to the riddle can be found in the two oval portraits. They show the likeness of David Bailly more or less at the time of the main painting, together with that of his wife in 1642. Accordingly the young protagonist has been portrayed in hindsight, as he may have looked maybe 40 years earlier, looking ahead to his future, which is now the picture's present. And of which he knows, as we know, that it will go the way of all flesh and end in a death's head.

"Then I looked on all the works that my hands had wrought, and on the labour that I had laboured to do: and, behold, all was vanity and vexation of spirit, and there was no profit under the sun."

Ecclesiastes 2: 11

Las meninas

Detail, oil on canvas, 318 x 276 cm
Madrid, Museo Nacional del Prado

In *Las Meninas* Velázquez created a highlight of European painting. By the standards of the self-portrait genre, it combines conventional features with a bold mise-en-scène. What is conventional is the self-depiction of the artist at work: the painter at his easel. But what an interplay of looks, reflections, appearances is generated on this easel!

Diego Rodríguez de Silva y Velázquez, painter to the royal Spanish court, chamberlain, chief marshal to the court, member of the Roman academy, is seen standing in a long room in the palace, but to us he appears shifted to one side, next to a high canvas. He has just taken his brush off the palette, in order to take it to the canvas, but his own gaze is not following this process. His eyes are not fixed, as one might at first assume, on the cheerful goings-on around him: not on the charming Infanta Margarita between her maids-of-honour in the mid foreground, not on the court midget with her escort, the dwarf Nicolasico Pertusato, who is teasing the sleepy dog in the right foreground, and of course not on the queen's lady-in-waiting and chamberlain in the middle-distance of this great hall with all its pictures. The painter's gaze is focused on us. On us?

Are we the object of his attention? The background provides enlightenment. At the back, right next to where a further chamberlain, the king's, is at this moment pulling the curtain to the side in the open doorway, and looking out towards us, or to be more precise, to where on Velázquez' canvas, which we only see from behind, a picture is taking shape: in this background a mirror is shimmering. We recognize in the mirror the blurred faces of the reigning couple, Philip IV of Spain and his consort Marianna. Their Catholic Majesties as a mere reflection? But what of? Either of a part of the as-yet-unfinished painting or as a direct reflection of the royal couple, whom we must then assume to be standing just where we happen to be.

One way or another, it can only be their majesties who appear painted on the easel picture. The actual picture before our eyes shows something that diverges from the picture on the easel. Thus we have a multi-layered interplay of transformations: firstly, two paintings form a differentiated unity; secondly, two different reflection principles correlate with each other, namely a reflection in a mirror (albeit also painted) with the artistic reflections represented by the painting; thirdly, the internal and external reflection-subject of *Las Meninas* is the royal couple and the painter, each in their different way, and yet jointly.

The amazement goes on. The fact that the painter positions the royal couple in the invisible space in front of the picture and only gets them into the picture as a reflection, while he himself reigns like a monarch within the picture, controlling the proceedings, is without parallel in the history of art. This staging becomes comprehensible when one remembers that it was through it, and only through it, that the absoluteness of the Spanish monarchy, which transcended the senses, was unified with the fiction of painting as an art. Apparent paradoxes of this kind thus serve the glory and dignity of the highest authorities. Precisely this service of authority is doubtless the actual purpose of the picture, and it is precisely with this compositional idea that Velázquez proves his extraordinary status as an artist. He serves the picture, and dominates it at the same time. He makes himself the compère of visible and invisible appearances.

"may you be inspired by the lofty figure /
of the greatest monarch in the world, in whose
appearance every / change is feared by those
who have the fortune, such / glory to behold."

Jerónimo González de Villanueva, quoted by Francisco Pacheco, 1649

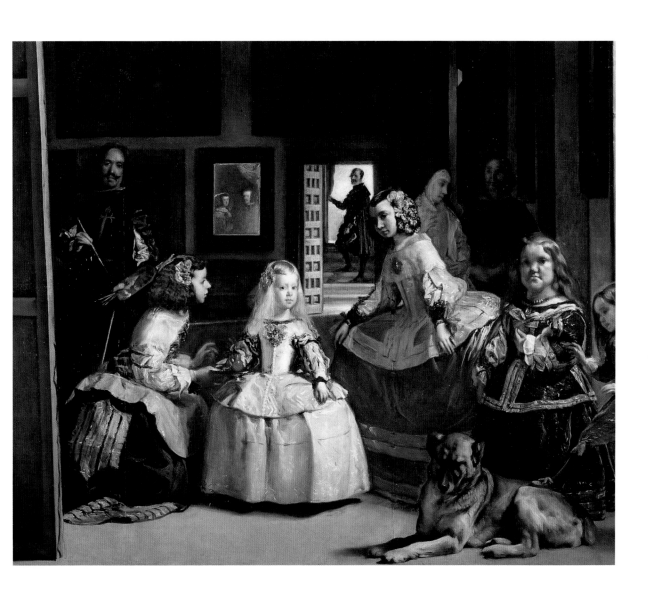

self-portrait as zeuxis

Oil on canvas, 82.5 x 65 cm (cropped)
Cologne, Wallraf-Richartz-Museum

No one in the 17th century played the game of literary and social roles so extravagantly and with so much variety as the Dutchman Rembrandt. In almost 90 self-portraits, he proved how autobiographical interest and the insatiable curiosity of staging could, time and again, bring forth different variations on the theme of self-depiction. Rembrandt's visual casting plan ranges between lofty personal dignity (representation as apostle or ruler) and base characters (beggar, fool, executioner). And at the focus of all his appearances facial expression is the dramatic, and often enough experimentally exploited field of constant metamorphosis. Role-play and existential profundity need not contradict each other in any way in this process. What that means, is demonstrated by this late self-portrait, now in Cologne.

From the warm dark tones of the background, there looks at us an old man, somewhat bowed. His figure is combined with the darkness in a fluid, unquiet form. Every part of this figure seems up to a certain point to be working towards its own self-dissolution. At least the brushstrokes serve not only to depict the face, the cap, the chain around his neck or the shawl of his cloak, which lights up like flowing gold, but also an autonomous play of colours and their substances.

This incessant movement leads us to think we see the figure of the man itself moving, and to devote all our attention to this movement. We know that this old man is Rembrandt, painted a few years before his death. That he is hold-

Self-portrait as Young Man, 1629

ing a maulstick and has a picture on the easel in front of him, on which he is currently working (we recognize chimera-like the profile head of an old woman at the top left of the picture), that shows him to be a painter. And we see that this gaze which the painter directs at us is crucial. Admittedly, the expression is no more definable than the play of forms with the paints from which it is built up. Pointed eyebrows, swollen lids, a mouth open so stiffly it could be a mask: is the old man laughing or crying? What does this giggling, whining laugh have to do with the work at the easel? What's it doing in a self-portrait anyway?

Certainly Rembrandt here, as so often before, was using grimace and a bowed body as experiment. It interested him to explore, with the limiting situation of his own appearance, the particularities of expression. Decay, pain, mockery – these had to be brought to the latest state of visualization.

For this man was not just old and doddery, he was regarded by those who knew him as worn out. In 1656 he had had to declare himself bankrupt, and had already had to conduct humiliating litigation against members of his own family. He was receiving few commissions, wives and children had predeceased him. Now, at the end, he seems to be taking stock, between laughing and crying, and once again he finds a role to illustrate it. It is that of the "laughing Zeuxis". The famous classical painter Zeuxis, had, according to legend, laughed himself to death when he was required to paint an old woman in the role of Venus, the goddess of love (the head on the left of the picture would, therefore, belong to this ridiculous sitter). In Rembrandt's case, however, this mythical laughing-to-death has been toned down to bitter irony. It applies to everyone, not least to him. The excitements of art and life now appear in a definitive light.

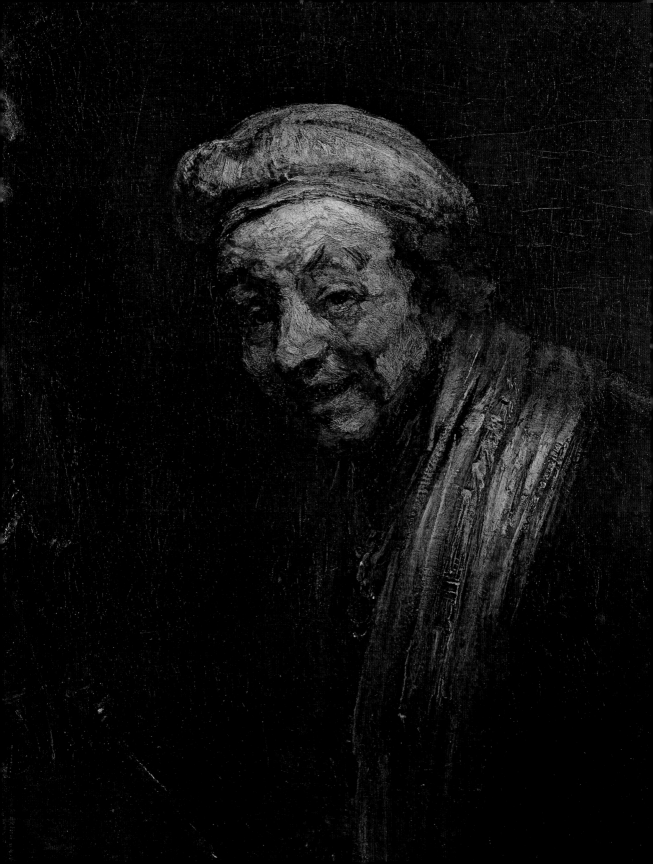

self-portrait with a portrait of her sister giovanna

Pastel on paper, 71 x 57 cm
Florence, Galleria degli Uffizi

Among her contemporaries, Rosalba Carriera was regarded as the most famous woman painter of the first half of the 18th century, if not indeed as the "queen of Venice". In Venice, "la famosa Rosalba" ran a salon where society ladies went to see and be seen, and where merchants and aristocrats who were passing through felt duty-bound to have their portraits painted. In 1705 she became the first woman to be elected to the Accademia di San Luca in Rome, in 1720 to the Bolognese Academy, and when she went to Paris in 1721/22, where she was also elected to the Academy, her pictures unleashed a veritable fashion frenzy.

What was the secret of her success? She painted – it would be no less true to say that she drew – with pastel crayons on softly tinted paper. Pastel colours are rubbed dry on to grainy paper in the form of a soft, powdery pigment with little in the way of binder, and they stick to the paper as a layer of coloured dust. As pastel colours can hardly be mixed by applying them on top of each other on the paper itself, the colour richness is created mainly through the juxtaposition of the powdered pigment. The palette of crayons has to be correspondingly elaborate. But the rubbed pastel never had a lasting quality. For this reason the intimate magic of pastels was identified with luxuriously "superficiality" at an early stage, although in 1720 that concept had not acquired its modern negative connotations. Beauty, that was charm and chance in the play of effects. Powder and periwigs were all part of it.

And yet: while the *jeunesse dorée,* the aristocratic mistresses and the notorious courtesans all laid siege to Signora Carriera's studio, it was because the portraitist knew how occasionally to enrich the external charm of skin and costume with penetrating, characterful and emotional elements.

The mistress of the studio herself was if anything of austere appearance. Sources describe her as reticent: chaste, bourgeois, worthy, pleasant enough in her manner, but with something of the old maid

about her. In 1746 an eye complaint forced her to abandon her career, and the end of her life was marked by deep depression.

Carriera's self-portrait, dating from 1715, gives us some inkling of the many sides of her personality. The picture was commissioned by the house of Medici, in whose Florentine portrait gallery the already famous painter was to take her place. We see her slightly inclining to one side, her gaze confidently directed towards us. While the smile on her lips is barely noticeable, the friendly eyes are a little serious. In her left hand the painter is holding a "picture within a picture", on which she is placing a brush with her right hand. In this way she is presenting to us her sister Giovanna, who was so to speak the unmarried artist's *alter ego* and housekeeper. Only with her help could Rosalba Carriera carry out her portrait commissions as she did.

In a roundabout way, then, we are being shown that the material, serious side of life is no less important than the testimonials to professional competence. The lighter side should get its due, but so should solidity and reliability. The composition scheme appears routine, the dual smile lively. The soft velvet of the coloration is matched by the mother-of-pearl richness of the hues themselves. Affection and reticence maintain their balance. We are shown that the theatricality of the period was not without its pauses for reflexion, its chill-out zones. In the register of intermediate tones, one would like also to find varieties of truth. Not the truth of harsh principles, but of soft transitions.

"not even guido reni could have done it better!"

Carlo Maratta on a painting by Rosalba Carriera, 1705

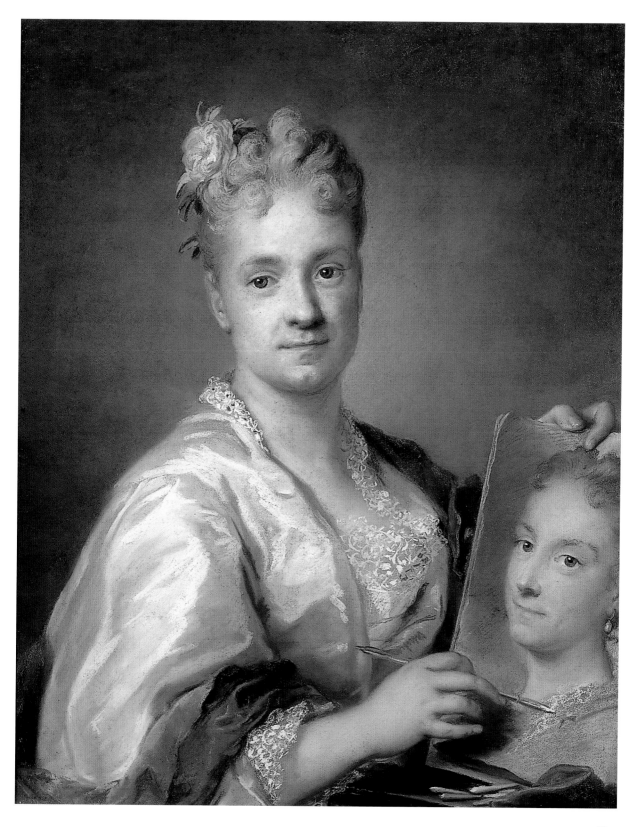

self-portrait with eye-shade

Pastel, 46 x 38 cm
Paris, Musée National du Louvre, Département des Arts graphiques

Artists do not always have to orient themselves by academic canons of value when they seek to find creative paths. However, they should then adopt new objects, develop new methodical means of idiosyncrasy that serve new or hitherto neglected possibilities of seeing. Chardin was one such idiosyncratic innovator. In the mid 18th century, when the Paris Academy laid down in its exhibitions what was supposed to be "beautiful", "true", "worthy" and "lively", he nurtured a concept that contradicted almost all these norms – and precisely as a result, he became the role model for several generations of artists.

Chardin's genre scenes and still-lifes, it is true, had their admirers in academic circles too, but they could never occupy the higher ranks in the hierarchy of values. On the other hand, thanks to Chardin, the eyes of bourgeois-Enlightenment art interests were increasingly opened up for the everyday-unemotional and the anecdotal-touching. Only a small number, three in fact, of Chardin's late self-portraits give a personal "face" (Hannah Baader 2005) to this outsider œuvre of his. But even these three examples display his characteristic innovations, such as colour decomposition, standardization of areas of colour, transparency of the optical seeing process, intimization of the ambience.

The late contemplation of his own face has to do with an eye problem that forced the artist to give up painting in oils. Toxic solvents had provoked allergic reactions. After 1771 Chardin worked exclusively in pastel as a result. This head-and-bust view brings the face close to the beholder, importunately close in fact. This happens without any spatial elements, or any gesture, to back it up. A simple coat and a loosely tied neckerchief bear witness to a private, unofficial occasion. Attention is reserved for the head alone. So it is all the more surprising how this head is projected into the picture. The spectacles make the painter come across as somewhat paternal and quirky, and give his gaze behind the glasses an empty look. By contrast, there is nervous tension in the mouth. An eye-shade, which is secured by a cloth knotted round his head, gives the painter the final note of eccentricity. There is an uneasy balance between the nearness of the face and the detachment resulting from the glasses and eye-shade.

This unease is reflected by the technique. For in a way all of their own, the pastel application and the material shift between technical matter-of-factness and idiosyncratic effect. Pastel colours cannot be mixed, and only up to a point can they be applied one on top of the other: the painter is thus forced to place finely-nuanced tones in juxtaposition. In the eye of the beholder the porous hues coalesce into pale, weakly contoured colour masses. In fact Chardin was only repeating the "impressionist" brush technique of earlier days, albeit now translated from miscible liquid paints into dry, powdery pastel. A sensitively gradated spectrum of tones covers the surface of the picture with a fleeting layer of pigment that cries out for fixing, glazing and protection from the light. This corresponds to the indistinct gaze of the painter, which we have the impression is seeking for clarity behind the lenses.

Self-portrait at the Easel, c. 1779

self-portrait in studio

Oil on canvas, 42 x 28 cm
Madrid, Museo de la Real Academia de Bellas Artes de San Fernando

Francisco José de Goya y Lucientes is one of those legendary crossover phenomena in European art history without whom the path to modern art would be barely comprehensible. He is legendary although, or precisely because, he himself on many occasions and in many ways undermined, transformed and in some cases overthrew the norms of style, and the traditions of motif. Many historical currents assume in him their sometimes dreamy, sometimes gruesomely realistic face: as individual psychogram, as social mask, as the grotesque face of faith, superstition and morality.

There are other ambivalences too: Goya was a painter and graphic artist of equal standing, a story painter and portraitist, a depicter of mores and of fantasies. Since he saw chaos and the abyss in order, madness in sense, and hierarchies turned on their head, he became one of the chief precursors of modernism. Goya was a figure of the Enlightenment and at the same time an Enlightenment sceptic, a Romantic and a critic of Romanticism. If he believed in anything at all, it was in the compositional power of art to overcome all absurdities. His whole life was characterized by conflicts between career and conformity. Goya oriented himself by values which he had to admire, despise and fear all at the same time. Accordingly, his life story moves between the light of success and the shadow of depression.

Shortly after 1790, the actual crisis came. Goya may have arrived on the scene, filling influential posts such as the deputy directorship of painting at the San Fernando Royal Academy or that of *pintor de rey,* even of *pintor de cámara* (court painter). On the other hand, he stood on the threshold of serious illness, which led from 1792 on to progressive deafness. Goya reacted by withdrawing to private life, but above all by an introverted pictorial language. Puzzling features grew more numerous.

His small-format self-portrait in the San Fernando Academy is now dated to c. 1794/96. Outwardly it draws on Velázquez' *Las Meninas* (ill. p. 49). Here as there, the painter is standing full-length at the edge of a canvas in shadow, and here too we cannot see the picture which the painter – albeit here in the bright light of the studio window – has in front of him and on which he is currently working. We only see the gaze he is directing towards us, as though he were portraying not himself, but the beholder. Are we standing – in contrast to the earlier picture – in the place occupied by the mirror in which the painter is studying his outwards appearance? Are we his mirror, in the metaphorical sense? It would also be conceivable that we are disturbing the painter at his work, which would also explain why his facial expression seeks to be more precisely interpreted. What should we read in the dark eyes? Precise self-observation, or a reluctant hard stare at uninvited studio guests?

Whatever the case may be: no chamberlain (and court protocol did not accord this function to Goya) makes an appearance here, no master of ceremonies. Instead, we encounter a man of about 50, who has been turned into a shadowy figure by the light falling from behind. His fashionable hat, in fact all the fashion appurtenances of a *majo* (the minor aristocracy who could usually be seen strutting along the streets of Madrid), give his silhouette a certain boldly elegant outline. Sometimes he too could be a little vain, this sceptic on the edge of the shadow.

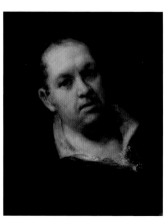

Self-portrait, 1815

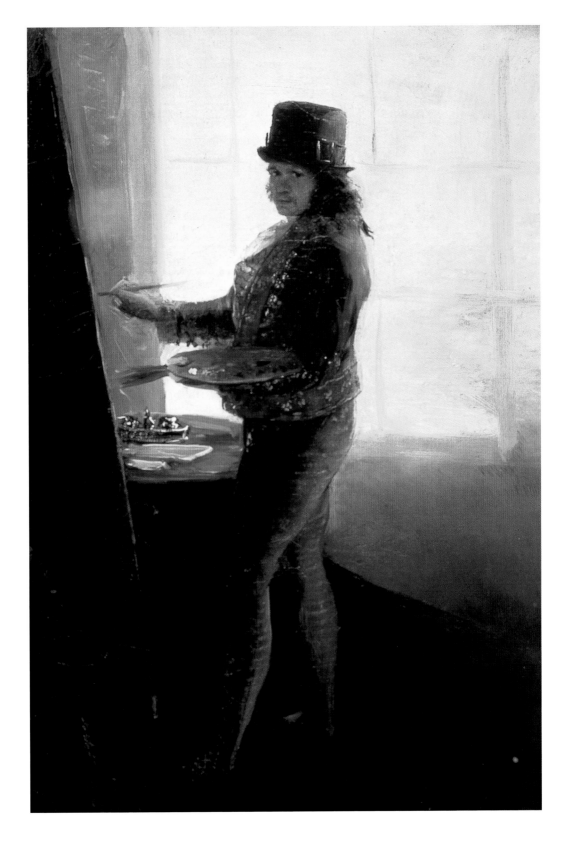

self-portrait with Bandaged Ear

Oil on canvas, 60 x 49 cm
London, The Courtauld Institute Galleries

Michelangelo portrayed himself in a piece of flayed skin, (ill. p. 37), Caravaggio in the severed head of Goliath (ill. p. 39). But whatever personal reasons there may have been, these are artistic conceits. Vincent van Gogh by contrast, in two versions of *Self-portrait with Bandaged Ear,* presented himself as someone who had actually committed an act of self-mutilation. On the threshold of modern art, the destruction fantasies of melancholic geniuses had become deadly serious.

Van Gogh's self-revelation is to this extent a document of desperate need for therapy. For what happened in Arles on 23 December 1888 and provided the occasion for this picture is one of the founding myths of the modern, God-forsaken artistic destiny. After a row with his friend and fellow-artist Paul Gauguin, he wandered aimlessly around the town, and suddenly turned up with a razor in his hand at the brothel in the rue du Bout d'Arles, where he handed a prostitute named Rachel his severed ear-lobe – a relic, so to speak – with the request "to keep it safe". He then staggered home, where the police found him the next morning just in time to get him to hospital before he bled to death. The doctors said it was an attack of alcohol and schizophrenic self-aggression; no, just an "artist with a screw loose", said the patient a few days later. And as it was "necessary for healing", he immediately painted another self-portrait.

At the point where the bandage encloses the wounded ear, just beneath the axis of the eyes, the line of the edge of a canvas standing behind him in the studio meets his head. Every point in this picture is, to quote the artist's own words once more, "of unheard-of electrical tension" (December 1888). The green coat, which forms a plinth for the face with its serious, far-apart eyes, has been given the clearest texture. But the other features too – the cap with its fur brim (it's winter in Arles!), the easel, the visible portion of the door, the wall with the Japanese woodblock-print – evince densely woven, short, gesticulated brush-patterns. A few strong shadowed edges serve to structure

colour-fields that range from green permeated with white to indigo and yellow. In the face these colours re-appear in small areas, and here we also see the sparsely applied orange and red accents which warm up a total impression which is overwhelmingly cool. The bandage, shirt and canvas highlight the composition with a wan white, as though they belonged together.

One may see it as weakness or boldness that the "heat centre" of the picture, in other words the colourful skin of the face, is immediately adjacent to the second colour chord, namely the large Japanese print, which has been identified. It is no less specific than the mark of self-mutilation on the other side of the face. The *Geisha in a Landscape* by Sato Torakiyo was in van Gogh's possession. It documents the extent to which the painter, to the very end, saw in the colours and lines of Japanese pictures the most important inspiration for his art. Colour for this unhappy artist was not just warmth, sunlight, a healing surrogate for love, but also a symbol of life generally. Wherever he happened to be, whether it was the bars of Paris or beneath the cypresses in the south of France, he tried to compose this warmth expressively. He had not felt enough of it in life. To feel himself while painting, that was for him there like an everlasting journey. For him, to be on the road with painting meant sensuous emotional bliss: an inward, erotic "Japan".

> "I hope it was just an artist with
> a screw loose, and then a high fever
> caused by the severe loss of blood,
> because an artery had been severed."
> Vincent van Gogh, 1889

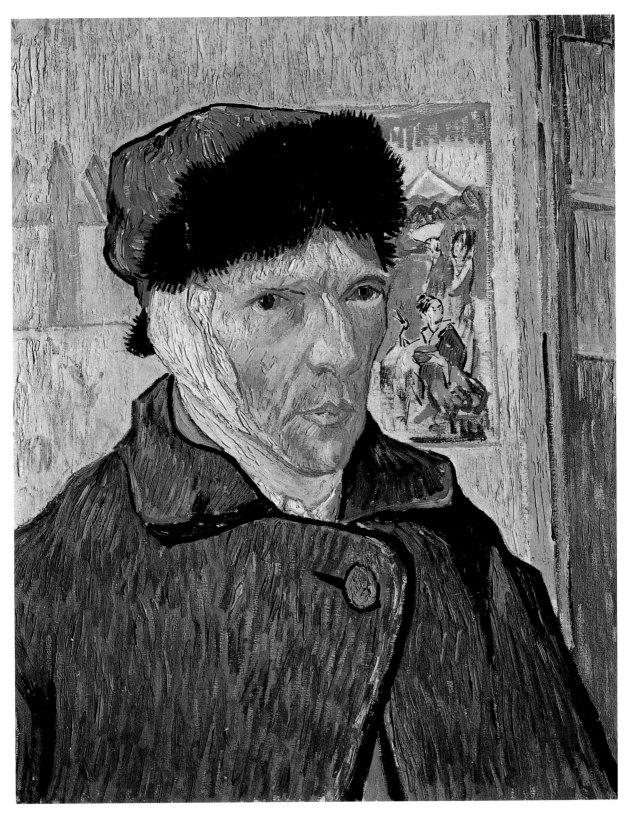

self-portrait with cigarette

Oil on canvas, 110.5 x 85.5 cm
Oslo, Nasjonalgalleriet

By 1895, Edvard Munch had his first successes and first scandals behind him. Following several trips to Paris, and from 1892 longer sojourns in Berlin, the painter who was beginning his career in Kristiania (modern Oslo) had become captivated by the hectic flair of cosmopolitan life. To find his own place in the front line of artistic developments obliged him to take up the appropriate lifestyle. For a bohemian plagued by crises, so long as the rise to *haut bourgeois* representational styles was denied him, there were two options: monkish withdrawal, working in the spirit of poverty and loneliness on the one hand, or to play the *flaneur.*

"Monks" react to the growing complexity of modern life by renouncing distraction, *flaneurs* by contrast devote themselves to it. Under the shelter of the one or the other attitude, one could at any rate find security. Scope remained for experiments, and there was time too for working over self-doubt. As circumstances dictated, Munch pursued both styles. The *Self-portrait with Cigarette* reveals how he wished to see himself in 1895.

The very illumination is confusing. As though a flash were coming from the floor, the light rakes the man standing in mysterious darkness. There is enough light to see that he is wearing a suit and bowtie, as he stands there, depicted in three-quarter length, holding a cigarette between the fingers of his raised right hand, and that his staring face is dazzled by the flash, as though it were hanging onto a thought or looking in amazement at someone who had unexpectedly turned up in front of him.

Are we supposed to see how he has suddenly "seen the light"? How he, in a flash, has comprehended something which we are to share with him as a moment? As we can pin down the smoker neither in his thoughts nor in a specific action, except for his staring, thinking and smoking, we have all the more reason to see him in his particular situation as a painter. We then notice a process that so to speak portrays itself. Light and shade (night time) are only the pretended reason for his appearance. It stands to reason that they can and must be associated by an unquiet spirit strolling through the nights. For when does the hour of inventive spirits strike, if not in the lights of the recently electrified cities, of illuminated shop-windows and variety billboards? And where else, if not in the all-night cafés or on the way to them, can one reflect on new books, on new pictures that have been created during the daytime?

But really adequate, this consideration is not. Munch's so finely modelled hand with the cigarette helps us along. The ultramarine and cobalt blue that so to speak "rises" in the cigarette smoke, sinks down in the transparent glaze towards the edge of the picture, dissolving the figure and the surrounding space. The rising smoke is mixed with opaque white, producing a more solid paint layer than the thin paints used for the room, in places smeared right down to the canvas. Rivers of blotches, streams of drops of paint, traces of scratches in the paint form, along with contour lines, a reality of their own in this painting. Munch's figure is surrounded by this painterly movement as by a protective aura. (The neutral portrait background has always been one of the secret birthplaces of abstract painting; after all, as a space without objects, it remains free for moods and expression.) The painting process here doesn't serve to create a self-depiction, it *is* to a large degree the self-depiction.

> "I feel that I am distancing myself
> further and further from the taste
> of the public. I feel that I shall create
> even more annoyance."
>
> Edvard Munch, 1891

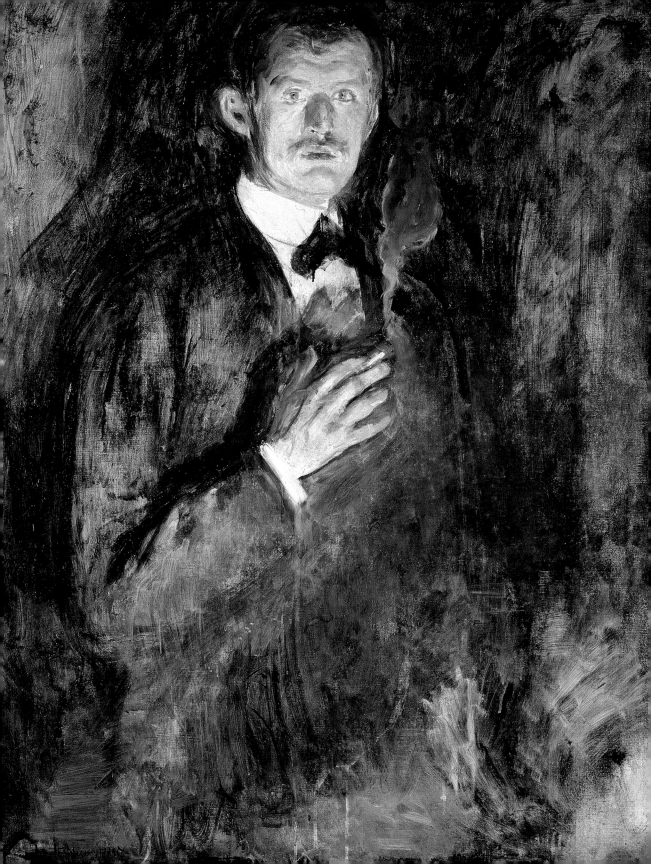

self-portrait among masks

Oil on canvas, 117 x 82 cm
Komaki (Japan), Menard Art Museum

Mask and individual seem to be opposites. Artist self-portraits, which often make use of role-play, also attach importance to this difference. For in individuality artists demonstrate uniqueness, in masquerade their protean capacities. On the one hand the emphasis on existential autonomy, on the other communication in the variety of cultural appearance. James Ensor, the droll loner from the Belgian port of Ostend, not only emphasized these poles in their interaction, but demonstratively reversed them. How otherwise could he have demonstrated his own ambivalent attitude to each, in other words, to himself?

This famous picture, painted in 1899, brings out this bipolarity by covering it with a different tension, namely that between the individual and the mass. The surface of the portrait-format picture, filled with masks, becomes a mass rally. Some of the masks have empty eye-holes, while others may conceal living faces. Grimacing larvae, grotesque spectres from the world of carnival, ethnographic souvenirs or curiosities – they are all monstrously jam-packed next to and on top of each other. Between death's heads, the final mask of our existence, and doll's-head chimeras, the searching eye is disgusted rather than amused.

But where is the individual in all this? It can be found as a half-mask in the turbulent throng. In the top quarter of the picture, an effeminately aristocratic-looking bearded figure stares out from the confusion of visages. On the Rubens-like blasé head (it might also be described as elegant à la van Dyck), which looks affectedly but with a serious expression over its shoulder, is a wine-red hat decorated with a feather. So that is himself, Ensor, the mask-painter.

Certainly his sculpturally extended and individual bust rises out of the garish crowd, but by quoting the virtuoso world of Flemish Baroque, in order to characterize himself as a despiser of modern mass noise, he slips back after all into the world of stand-ins from which he precisely wanted to escape.

Or did he? Who was this Ensor? In life and in art, he was two things in one, a denier and a worshipper of the mask business. Above all he saw himself as a bringer of salvation. Like a new Christ, Ensor sought to help the mass of the alienated, those robbed of their identity, find themselves again. The lonely individuals of the early industrial age, the crowded occupants of large hostile cities he sought to redeem with figural splendour and symbolist magic. To put on and take off the mask, to reveal it even as the germ of all pleasurable and distressful turbulence – that was his programme.

James Ensor himself was under the spell of masquerades. He grew up surrounded by shells, exotica and carnival paraphernalia in his mother's souvenir shop. In a certain respect, therefore, we can see in the self-portrait of 1899 a piece of window-dressing that represents this childhood fascination. A love-hate relationship with the world of processions, stage appearances and curios provided the impetus for Ensor's artistic development. From 1886, he had increasing success, but before that, this otherworldly fantasist had to put up with the teasing of critics and fellow painters. Thus this painting is also a site of what Sigmund Freud a few years later was to call "narcissistic insult". Accordingly, the picture could be an affront. The grimacing masks surrounding the artist would then be his critics and fellow artists.

"For me the mask stands for freshness of tone, exaggeration of expression, splendour of decor, grand unexpected gesture, uninhibited movement, exquisite turbulence."
James Ensor, 1887

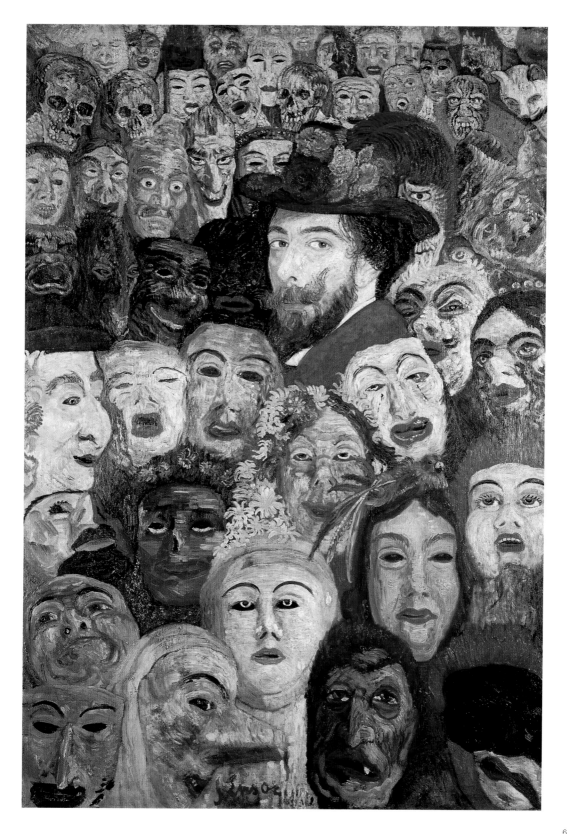

self-portrait with palette

Oil on canvas, 92 x 73 cm
Philadelphia (Pennsylvania), Philadelphia Museum of Art, Albert E. Gallatin Collection

If over the centuries individual likeness and physical illusion had set the standards of portraiture, after 1900 it was above all Picasso who ushered in the renunciation of personal likeness. What that means is exemplified by his 1906 self-portrait.

We have a picture in which the pale areas of dull cream come up against abrupt dark colours. The figure and the background are raw forms. A blue-grey background, whose dull paint is vibrantly applied and mixed in such a way that it borders on the dirty, sets off the half-length figure of the artist. It is modelled with just a few excursions into grey, and almost frontal to the beholder. However there is no eye-contact. The fact that the two-dimensional, self-contained figure "is" the artist, is clear from the palette, which for its part is held in such a way that it is parallel with the plane of the picture, but also so that it coincides with the grey of the trousers, and thus immediately becomes two-dimensional once more. This is the only conventional part of the picture. Only here, this once, did Picasso include the standard attribute of the palette in a self-portrait.

In other respects too there are differences and causes of confusion, especially if one considers what would normally have been expected of a picture in 1906. That the artist was wearing a collarless shirt, such as would have been worn by working-men, and is thrusting his right-arm, with the shirt-sleeve rolled up, into the waistband of his trousers, contravened the norms of pose and dress. The canon of propriety, in minimal form at least, applied even to Montmartre's bohemians in 1906.

And now the colours! Artless, raw, inelegant. Everything designed to provoke. The shirt-cum-overall is dominated by the straight-line-contoured two-dimensionality, the right arm by contrast appears to be sculptured with all the creases around the elbow, but this plasticity in turn comes across as confusing. Is the elbow in front of the shoulder, or behind?

And finally the head, the face! Where, if not here, must the essence of a portrait prove itself? The head is ovally stylized, its cropped hair does not correspond to Picasso's actual, appearance in 1906. But it does fit in with the abstract contours of the facial features, the staring almond eyes or the shadow of the arm, all of which, schematized, have taken on a spooky existence of their own. Like someone wearing a mask, staring past us, the young painter is standing in a room which is no longer a room. Defamiliarized, deformed, geometrized: that is how the figure appears. A likeness between the person and the picture exists to the extent there is a likeness between sound and noise. How can someone treat his own appearance in such a "primitive" manner, staking everything on the raw "noise" of colour and form?

On his journeys in 1906, Picasso had seen Old Iberian cult figures, and previously African and Oceanic carvings in the Musée de l'homme in Paris. He was fascinated by the magic of these items, he enthused over their coarseness. He recognized that a new start had to be made with this pristinity of vital spirits and beings! Their distance from all academic beauty, indeed their fearful, mysterious ugliness: these were the path to new truth in art. In the 1906 picture, the first steps could be tried out on his own body.

"you had better make a note of his name: picasso!"

Eugène Marsan, 1906

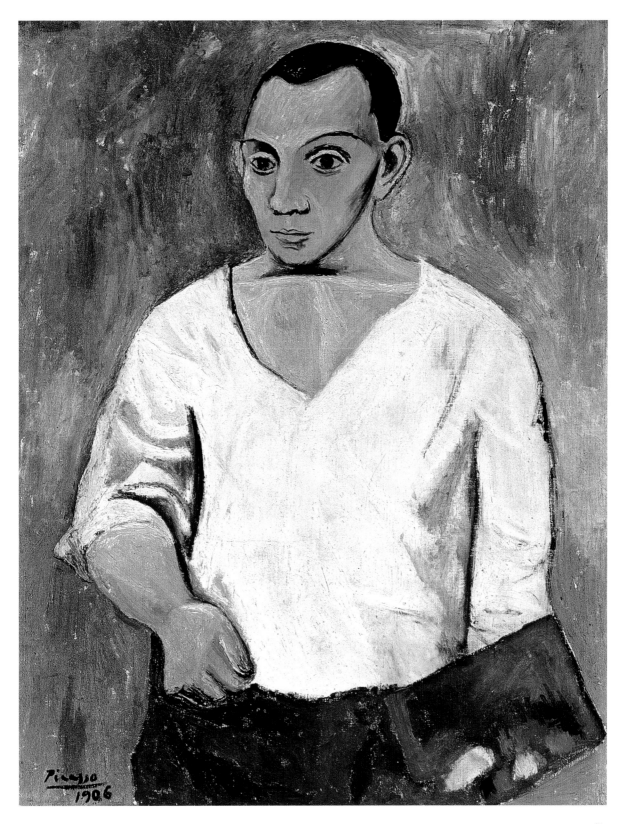

self-portrait with вlack clay vessel

Oil on panel, 27.5 x 34 cm
Vienna, Historisches Museum der Stadt Wien, bequest of Arthur Roessler

Self-portraits are never just mirror-images. The reflected self is actively processed: clarified, enhanced, often mysteriously defamiliarized. If we use the jargon of modern cognitive science and say that the underlying self-image is "constructed", this expression can be taken quite literally where portraiture is concerned. For a physical and psychological presence is like an edifice, when artists "build up" human characters in the proportions of pose to facial expression, from the bodily plinth to the turn of the head, from the gesture to the frame. This is all the more enlightening in those phases of art history which revolutionize the traditional order.

When, in about 1910, during the first heyday of avant-garde radical concepts, the old pictorial systems were being exploded in Vienna too, it was Egon Schiele's self-portraits in particular that tested this

**Standing Male Nude
(Self-portrait), 1910**

process drastically and constructively. In our picture Schiele is presenting himself with curiously spread fingers. The whole body, the whole surrounding space seems to be under pressure and tension. Spaciousness and calm are missing, the beholder's gaze is drawn into painful constriction. Hard, in a vehement counter-rhythm, the half-length figure presses into the left-hand half of the picture, in such a way that away from the left side of its body the areas of an indefinitely marked two-dimensional space that remain free are all the bigger. Schiele has pulled his left arm like a chain close to and around his

upper torso, his hand spread to form a V-shape. A melancholy state beneath raised eyebrows meets our gaze. It all happens as if this scrawny black-shirted figure needs to provide proof of its multiple distortion. Where the forces are exerted so one-sidedly, counter-impulses are needed to open things up.

Next to Schiele's head, towards the middle, there is therefore a vaguely patterned dark mass. It contrasts and complements. Only gradually can it be seen to be a black, head-shaped clay vessel, with nose, lip and eye. Its relationship to the feverish and sickly flesh-colour of the face is that of a monster mask to the natural face, or a nightmare to a daydream. Just a few coloured accents, whose objective origin (garments, spines of books?) is barely identifiable, structured the white and wan-green empty spaces, which in turn are reminiscent of distempered house-fronts or primed canvases. Only a tender branch with leaves at the top right breaks through the mysterious weave of flat areas with a hint of nature and the outside world. Confined and wide-open, beautiful and ugly, form and deformation are mutually reassigned anew, literally under tension.

In other works too, Schiele experiments time and again with the oppressive trialogue of body, space and surface. When in 1914 he was given a wall-sized mirror, he adopted some curious poses in front of it for his photographer friend Anton Trčka. Thus he echoes the frame geometry of the mirror, locks himself in and at the same time hints at bursting it open. His own body is for him a trial-run for new pictorial architecture. He seeks to use it to examine how to build up figure-like arrangements while breaking down the tensions of emotional life.

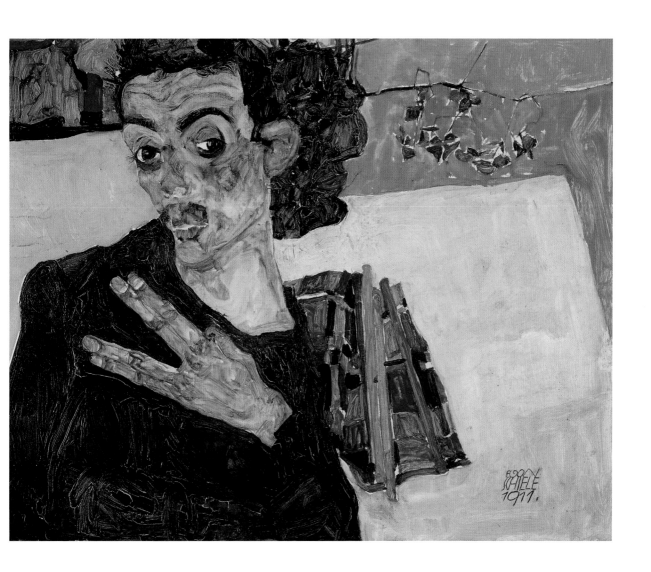

self-portrait with model

Oil on canvas, 150.4 x 100 cm
Hamburg, Hamburger Kunsthalle

"Expressionists" was the name given in Germany from about 1910 to those painters who expressively enhanced form and colour as autonomous features in order to translate the fundamental emotions (fear, grief, rage, curiosity) of modern metropolitan man into signally effective images. Ernst Ludwig Kirchner's works are among the earliest and most powerful evidence of this expressive will in Germany.

Kirchner was the leading member of the group of artists formed in Dresden in 1905 known as "Die Brücke", that is to say, "The Bridge". Until 1911, the members had a joint studio in the Berliner Strasse in Dresden. Here they hoped to realize their utopia of a free and creative existence at least fragmentarily. They painted, partied, drank, danced, made love, friends came in and out; this was the base for night-time jollifications and day-time excursions to the Moritzburg lakes. In order to lend this little paradise the proper inspirational strength in the optical sense, too, Kirchner decorated the working areas and sleeping alcoves with painted hangings. Thus in 1909 the studio resembled some exotic dream destination located somewhere between a South Sea island, a "Negro kraal", a Bedouin tent and a Buddhist temple.

In the *Self-portrait with Model,* which was begun in 1910 and revised in 1926, Kirchner appears in a kind of dressing-gown reminiscent of the contrast-rich patterns of Indian ponchos. The painter is smoking a pipe, standing with his palette at the edge of the picture, as though the easel began just at this edge

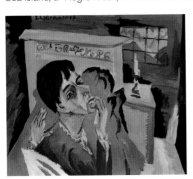

Self-portrait as Sick Man, 1918/20

and as though there were a mirror occupying the position of the beholder. Kirchner depicts himself at work, in the midst of the ecstasy of his colours. The brush in his left hand has just been dipped in red paint, in other words the prevailing tone which keeps the deliberately placed green of the picture at a complementary distance. In the same way, the orange and violet stripes of the dressing-gown contrast with each other.

The harsh colour contrasts interact in this picture in such an excited fashion, their interplay is so lively, that the figures are the last thing one initially looks at. In this sense, the girl sitting at the back of the studio is only registered as a contrasting chord, because the painter's dark look is not directed at her (is she a model? a girl-friend?). However, the colour of her vivid sky-blue dress does reappear in the colour of the palette, just as the orange-pink of her legs finds its echo in the corresponding stripes of the dressing-gown. The walls, curtains, floor and shoes are also crying out to be seen as participating colours, or to be precise, as those emotions which match the drama of cold and warm, luminous and saturated colours. The colours in this game are supported by the scaffolding of contours. But this scaffolding, too, is, strictly speaking, colour: a massive structure of dark, almost black shadows.

What drama is being performed? And why is Kirchner's individuality taking second place behind his garish formal language? Where is he himself, the lead role? What we have is the drama of direct, unmediated vitality. Like van Gogh, Munch, Picasso or Schiele, Ernst Ludwig Kirchner appears as the embodiment of painterly freedom itself. As a model that does not serve to hint at the contents of thought, but stands immediately for his own vitality. For the unity of painting and "modern life".

self-portrait with cropped нair

Oil on canvas, 40 x 28 cm
New York, The Museum of Modern Art, gift of Edgar Kaufmann, Jr.

The œuvre of the Mexican artist Frida Kahlo must be accounted part of the inventory of Surrealist portraiture and of the symbolist folk art of her native country. The painter herself always opposed such categorizations. Even so, it was precisely in the context of such stylistic labels that she achieved considerable fame. The basis was her tragic life-story, burdened as it was with a serious road accident, miscarriages, a marital fiasco, jealousy, alcohol problems and life in a wheelchair. Her biography also includes a talent which objectively, it is true, could not flourish as it might, but subjectively sought ever new ways of self-testing. Self-taught, in 1925 she suffered a traffic accident that was to change her life. But it was only as a result of this accident that her narrative, symbolist painting developed that intensity, that communicative power, from which she could still derive a purpose in her harsh fate. And besides, Kahlo was a communist, so her relationship with the world was not purely contemplative, but very practical, political and contentious. At the same time she knew that not even agit-art can do without meditative space. As we have known since van Gogh, such a many-layered tension-field of crises and suffering is highly beneficial to the culture industry's need for gossip and kitsch.

This 1940 picture depicts the artist in a phase of her life in which she at least at times was not chained to a hospital bed or wheelchair. She presents herself sitting in an empty room. Clothed in a man's dark suit, she is looking at the beholder not only full of calm, but with pride and defiance. Months earlier, she had been divorced from the painter Diego Rivera, the man she loved like no other and who caused her to suffer to the point of despair. In her right hand she is holding the scissors with which she has cropped the splendid long hair known to us from many other pictures. There are bunches of hair and pieces of plait everywhere. In the upper portion of the picture is a line of music with the appropriate text. She is providing a bitterly literal note of defiance: "Look, when I loved you, it was for your hair; now that you are shorn, I love you no longer." This is a Mexican love-song, which from a man's perspective sings of a woman's abandonment, and the situation of unfreedom that results.

Normally, both being abandoned and having one's hair cut off signify humiliation. And almost inexorably, divorce and loss of beauty lead for a woman in Mexico to a loss of honour So is this a demonstration of voluntary loss of honour? That would match neither Kahlo's proud gaze, nor in general the whole centralized seated pose in men's clothes. Is she demonstrating harshness towards herself? A contempt for self-pity?

Kahlo's answer could lie in the following message: one must hold one's head up precisely when this attitude is not attractive for any exterior purpose. For only with a self-determined attitude can we regain lost dignity. This would throw off the burden of femininity that was bought dearly enough in better times, because it always went hand-in-hand with servile beauty, with complaisance towards others. So away with the role of woman as "woman".

"some are born under a lucky star, and others are out in the dark… i'm one of those for whom it looks pitch black."

Frida Kahlo, 1927

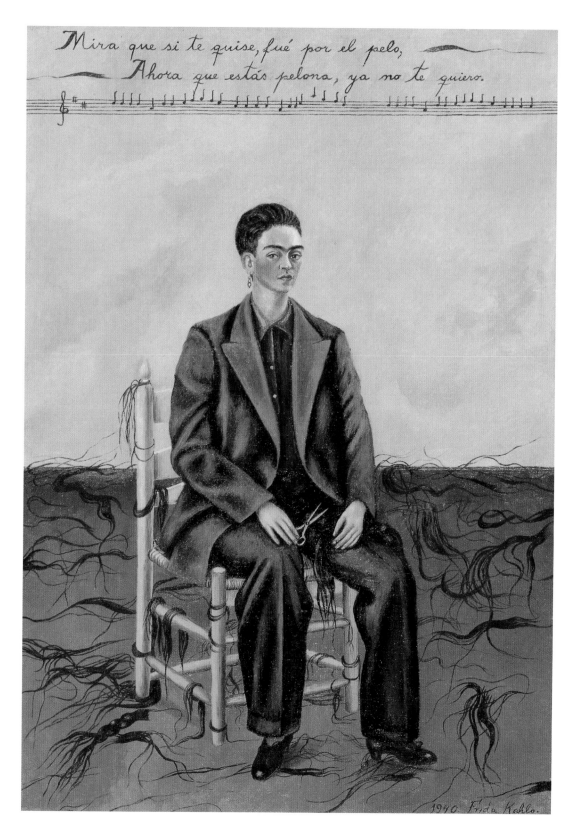

self-portrait with ɹewish ıdentity card

Oil on canvas, 56 x 49 cm
Osnabrück, Felix-Nussbaum-Haus, on loan from the Niedersächsische Sparkassenstiftung

The man turning towards us is standing in front of the angle in a tall wall which takes up much of the picture. His skin colour looks sickly, and he is somewhat emaciated. From dark eye-orbits emerges a serious, tense look. We can also interpret this look as vigilant or shy, for the way that it is directed towards us over his shoulder from under the brim of his hat, which only increases the shadow, behind a turned-up coat collar, does not correspond to any of the standard portrait poses. The man is standing so uncomfortably close that we can register his stubble beard, but actually we cannot comprehend his standing and turning as a statue-like pose: rather we see him as someone looking fleetingly to one side as he moves on.

A moving-on that is, specially for us, combined with a dual, secretly hasty pointing gesture. For while his eyes are openly looking at us, the man is showing us his ID card, which, because he is holding it so near, as near as his face, can be deciphered down to the last detail. The card has a red overstamp, the words JUIF – JOOD. This is the bilingual Belgian version of the Jewish ID with which the German occupiers stigmatized all Jewish people throughout Europe between 1940 and 1945, in order to register them thus for persecution, deportation and extermination. And accordingly too, the turned-up coat collar reveals his otherwise half-obscured Yellow Star.

The person secretly revealing himself to us in the twilight of some urban backyard is Felix Nussbaum. A painter of Jewish descent from Osnabrück in western Germany, he had lived in exile since 1933, from 1941 in Brussels, where he hid in basement and attic flats. In horrific conditions, he went on painting underground. His constant fear of detection would have paralysed many another artist. He retained his strength, the fear only spurred him on to more work. Underground, fear, energy – these are the words to describe his dark world of confinement. The wall looms over the man, and compositionally too it is oppressive. The spooky life on the patchy wet plaster behind him re-veals painting in oppressive matter-of-factness. Above the truncating effect of the cornice and its strong shadow, we can see a multistorey tenement block, pruned trees, dark clouds, and – like a shimmer of hope – a few white blossoms. There is also some light in a window of the building and on the masonry. But the darkness dominates.

With this self-portrait, Felix Nussbaum testified to the nameless terror of his situation. And also to his obstinate courage in responding to this terror with precise, narrative pictures. Far from all heroics, Nussbaum created a monument with this picture. The message: even when there seems no way out, one must not give up, because in not giving up, the last remains of dignity survive. Nussbaum is therefore not only speaking as an individual from the underground, he is speaking in pictures and gestures vicariously for all his fellow Jews suffering from persecution.

His – in any case meagre – hope of survival was not fulfilled. A few months later (he created a few more pictures in the meantime) Nussbaum was informed on, arrested, and taken together with his wife to Auschwitz, where they were murdered.

"ᴀs we must also account for our fate of facing an unlimited future, from there we find the strength that makes its demands upon us…"

Otto Freundlich, 1940–1942

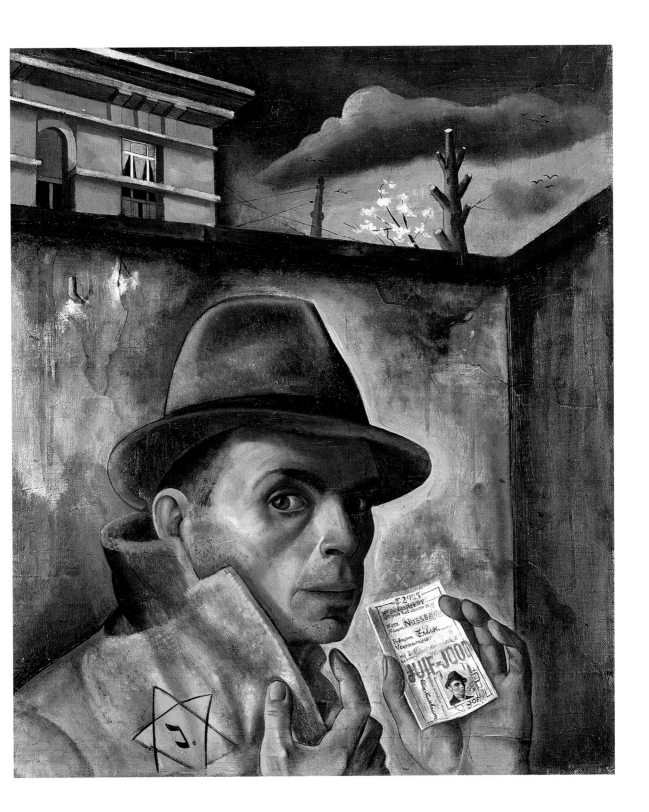

self-portrait

Oil on canvas, 95 x 60 cm
Munich, Bayerische Staatsgemäldesammlungen, Pinakothek der Moderne

Beckmann was one of the most effusive self-portraitists in the history of European art, whereby "effusive" refers only to the quantity and variety, but not to the character of the pictures. For, depending on his current situation at any one time, there is in his written and pictorial testimonials a more or less pronounced trait of scepticism, lordly aloofness, indeed of curmudgeonly caginess. Time and again this vulnerable and rebellious artist, perhaps the most important figurative painter alongside Picasso in the first half of the 20th century, examined his own psychological state. Indirectly he turned out, in the process, to be a sensitive seismograph of current events. Max Beckmann lived from 1937 in Amsterdam, in a kind of semi-official emigration. As a "degenerate" artist he was of course not allowed to exhibit, nor was he in any way totally safe from harassment by the German occupiers. Even so, he did not have to fear directly for his life, at least not in the time before the Allied air-raids. But he had to paint in secret. The manner in which his artistic eye was determined by the pressures resulting from his wretched life as an exile, and by a growing self-alienation at the same time, is documented by this self-portrait dating from 1944. Probably the darkest of all the Beckmann portraits, it is pervaded by an abundance of contrasts.

What characterizes this "sitting", and the word has more than its conventional portrait connotation, is the massive thrust forward combined with a block-like supporting background, his brusque turning-towards-us and mask-like finish, his unbroken strength and the floating "shadow of himself". In his dark suit, which he often used, so to speak, as a whole-body mask, Beckmann has positioned himself so that the back of his chair serves as a support for his left arm, while functioning as a protective shield at the same time. Beckmann is "hanging" over, rather than leaning on this shield. The fact that there is a cigar in his left hand, not immediately apparent, emphasizes casualness rather than rigidity. The elbow touches the bottom edge of the picture, as though tectonic support should be a question-mark. We have to decipher the face out of its dark silhouette, so to speak; striking highlights lend it a sudden plasticity. Brow wrinkles and a morosely obstinate mouth denote a sullen mood. The peering eyes seem to be staring no less bitterly at their own reflection than at the beholder.

The picture is characterized by a dyad of dark and light, black and white almost. But not everything is firmly fixed. In the highlights and on the chair-back there are creamy rubbed-down masses of paint, the beginnings of colour, which in places warm and soften the merely linear and black-and-white. Even the wan green in the face enlivens and opens up the silhouette somewhat. Thus ultimately the graphic dyad becomes after all a painterly, albeit dry chord.

Holding out in his Amsterdam studio at no. 85 Rokin, the painter quite evidently wanted to emphasize both his personal presence and his social withdrawal. He sought to put a barrier between himself and those who as organs of the state and representatives of barbarism threatened his life and his art. And he wanted, he had, to keep in contact with those relations and the few good friends who dared to enter his hiding-place. He had to be quick to act, he had to be able to show presence of mind, and yet he always had to be patient. For all this, Beckmann found a figure to absorb this bundle of contradictions. It is himself.

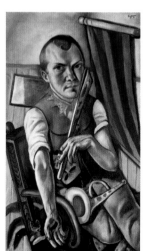

Self-portrait as Clown, 1921

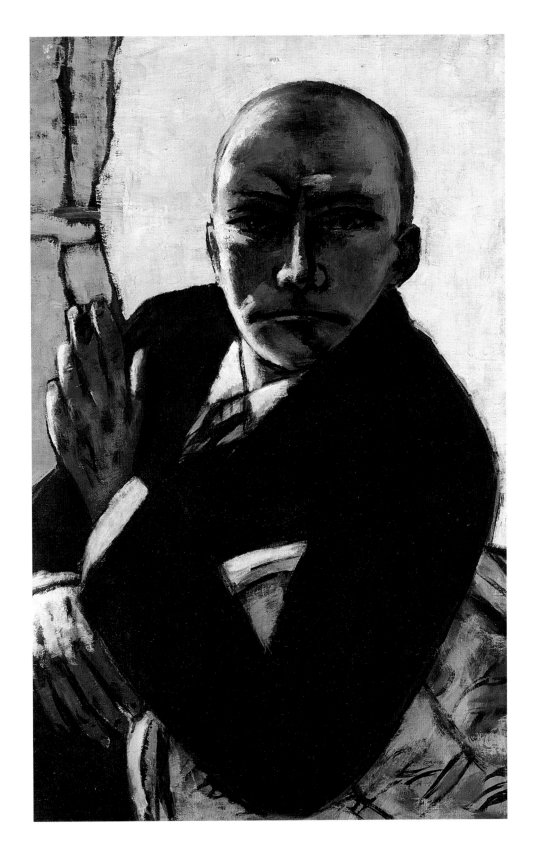

self-portrait

Oil on canvas, 31.1 x 25.1 cm
Houston (Texas), Collection Burt B. Holmes

The man facing us is not good-looking. But what does it mean to say someone is "good-looking"? For them to be of pleasing regularity of appearance, to embody the statistically infrequent union of "smooth" facial features, charming vitality and erotic attraction? In order to be authentically good-looking, should this appearance not also include the traces of life as it has been lived and suffered? For this, however, we use other terms: character, dignity, charisma… No, the aging Diego Rivera is not a good-looking man in the classical sense, not in the pictures that depict him as a young man, let alone in this self-portrait dating from 1949. But he did have the charisma that gave him authority and made him likable, and not least, attractive to women.

In his own way, this man was a major artist of the 20th century, a pioneer of political painting, militant in the struggle for popular liberation and the communist world revolution, an effervescent free spirit and an eccentric in his private life. Rivera knew all that. He is visibly aware of his war-weariness, that he is worn out. With a sceptical, tired look he sees in his reflection the ravages of time.

The line of his shoulders becomes a falling diagonal, over which the head with its tidy hair and the flabby, deeply furrowed face thrust forwards. The eyebrows are raised and vigilant, the lids are heavy. The mouth displays a barely noticeable emotion. The fact that one would describe the shoulder diagonal as hanging or falling rather than rising has to do not least with the bright and somewhat hectic background. This is full of lively details from Mexican "folk life".

Rivera's life, loves and works were full of contradictions: in American exile, he took commissions from the "class enemy" Rockefeller, and then became his dauntless critic once more, a leading member of the Mexican Communist Party, from which however he was expelled in 1929, because he opted for Trotsky and against Stalin. He was a man who could get passionately enthusiastic for almost everything, but not at once; he could be faithless to almost everyone and

every principle, and then loyally return to them. His passionate life was matched by an ecstatically searching art. It moved so contradictorily between the prevailing styles that he could often restrain the contents only through folksy exuberance. After he had visited Europe, and studied Giotto's frescoes in Italy as well as Picasso's Cubism and Modigliani's emaciated figures in Paris, he returned to his Mexican homeland in 1921 to combine liberation politics with liberation art. Two maxims determined the course of his art from now on. One: art must not be impartial, but must be suitable as a weapon in the war for communism; two: art must speak the language of the people, must educate the people, through pictures, to speak and to see. The most important medium for this was the history-narrative mural painting. On public buildings, monumental and instructive, the *murales* had to be composed in such a way that they teach, incite and give pleasure. Diego Rivera devoted himself to this task, but had at the same time to learn to recognize the limits of propagandist effectiveness and truthfulness.

"I want to be a propa-gandist. period."

Diego Rivera, 1932

self-portrait in Attitude of worship

Oil on canvas, 61 x 46 cm
Private collection

No 20th-century painter outdid him when it came to eccentric conceits or fantastical self-staging, no other artist served the myth of the unconditionally creative more manically, or at the same time more ideologically. But no other fulfilled these standards with such passionate craft perfection. This brought him, Salvador Dalí, overwhelming commercial success, and then, from 1940, when he went to the USA for eight years, the frenetic plaudits of the international art business. Dalí was a fashionable figure for decades. But he could not always win the appreciation, let alone the sympathy, of serious art-lovers. And to this day, while he is seen as a genius whose exceptional status in the history of Franco-Spanish Surrealism is undisputed, opinions continue to be divided on his aesthetic and artistic importance.

When he painted his self-portrait in 1954, at the age of 50, he was at the pinnacle of his reputation. Among the numerous components synthetically pervading his work, there are two above all that determine the concept, and both are significant in the 1954 picture. There is, first of all, what the artist himself had called, since the 1930s, his "paranoid-critical method": using physiognomic effects and suggestive spatial illusions, "dual images" are composed, which "tip over" from one to the other. Thus the naked man with the characteristic beard is kneeling both on the beach and under it, the calm, silvery water comes to lie on the thigh of the man as he gazes upwards in rapture, while his hand, casting a shadow, is supporting itself on the water as if this were a metal plate. There is a constant interchange of large and small, near and far. The coastal mountains in his hometown of Port Lligat near Cadaqués evince the same hallucinatory sharpness of detail as the nearby rocks on the beach. Such shifts in reality had been explored by Sigmund Freud as a perceptual principle in his interpretation of dreams and theory of neurosis (which Dalí had intently studied), the stored-up fears of the unconscious asserting their disconcerting power against all attempts at repression by the rational consciousness.

The second main component in the Dalí œuvre is, from the point of view of the 1954 picture, still very relevant. The artist himself called it "religious-nuclear mysticism". After the dropping of the atomic bomb on 6 August 1945, the ecstatic Catalan developed the view that God could be envisioned as the explosive coherence of the smallest particles and forces, and that in this spirit the modern world could be graphically brought to people's awareness in a newly conjured form and through all disasters. Thus the atomic model which appears like an hallucination above the simple nature of the sleeping dog is nothing other than the mystic vision of the inner world-principle.

The fact that in the centre of the atomic forces, beneath the exploding dome of the old world-edifice, the elements of a woman's face (we recognize Dalí's lover, muse and business agent Gala) spring apart and together, shows that the kneeling nude is here paying homage to his cosmos, which he himself has created and is united with him in delirium and erotic ecstasy.

"my mysticism is not just religious, but also nuclear and hallucinogenic."

Salvador Dalí, 1973

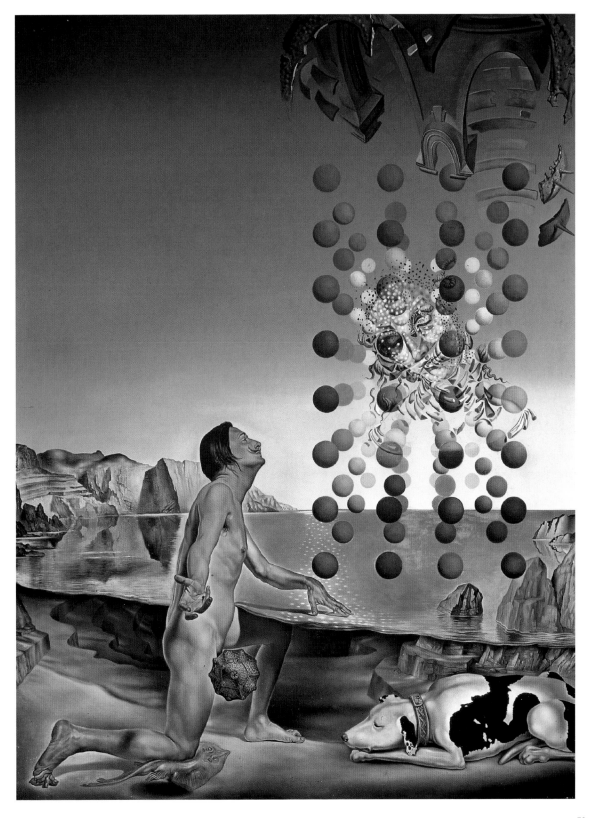

Reflection with Two children

Oil on canvas, 91.5 x 91.5 cm
Madrid, Museo Thyssen-Bornemisza

To this day, the taciturn, publicity-shy, interview-avoiding painter Lucian Freud hates other people watching him work. The grandson of Sigmund Freud, born in Berlin, he emigrated to London in 1933 and remained in his second home as a reclusive worker-by-eye, becoming a British national in 1939. His central theme has always been the human figure, the naked person, his or her unsentimentally and unprogrammatically denuded appearance: nature, warts and all.

Most of his sitters are people from his familiar environment: family, friends, fellow artists. By painting, he interrogates the material texture of their bodies. He sees psyche and world materialized in them in equal measure, and he seeks to reproduce this as directly and unsymbolically as possible. Without a doubt, he is following in the great "realistic" tradition of the 19th century. And of course, he has been compared more often than not to his famous grandfather. Both Freuds had, it is said, their subjects lying on the couch, so to speak, the one in order to penetrate the resistance of repression in order to get through, psycoanalytically, to true causes in the emotional sphere, the other in order to read, artistically, in the revealed skin the hidden interior, including his own. Both were, it is said, detectives using different means and methods to find what can only be made manifest on the surfaces of life.

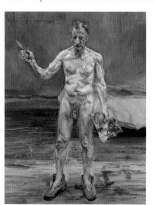

The Painter at Work, 1993

But while Sigmund proceeded from the symptom level to draw conclusions about the condition of the unconscious, Lucian remained with the phenomena of flesh and skin. His field of observation encompasses in particular worn-out and extinguished bodies. The skin is his criterion, according to which the emotional state and life-story of an individual, the lost or exhausted state of an existence, can be studied or characterized, but not judged. Skin is the boundary between body and life-story. Thus Freud became the specialist in pale skin, marked by liver-spots and with the veins showing through, in sagging breasts, obesity, carelessly spread legs and inflamed eyelids. Often the subject is depicted sleeping, coming across as ill or even dying. When they do seek eye-contact, they do not conceal their sadness.

And when Freud paints self-portraits, in other words looks at himself in the mirror while painting, it almost seems as though he had to transfer to his own act of reflexion, his dislike of being looked at by others. As though even the dumb mirror were loquacious. That's why in this 1965 picture the mirror must be taken into account as a factor in itself. The glass is tilted in such a way that it draws the eye of the beholder from bottom to top, and conversely reveals the eye of the painter, directed at himself, as suffering and surly, not so much condescending as dejected. We are looking up into a monotonous, barren ceiling, the corner of the artist's mouth, nostrils and eye-orbits forming a focus no less distorted than it is precise. The figure looks at us like the ceiling – all colours and none – or the coldly illuminating hollow of the lampshade: dull and sharp at the same time. It is just the two children on the floor in the background, on a different level of reflection, who are relaxed as they watch the proceedings. An exception is made for watching children.

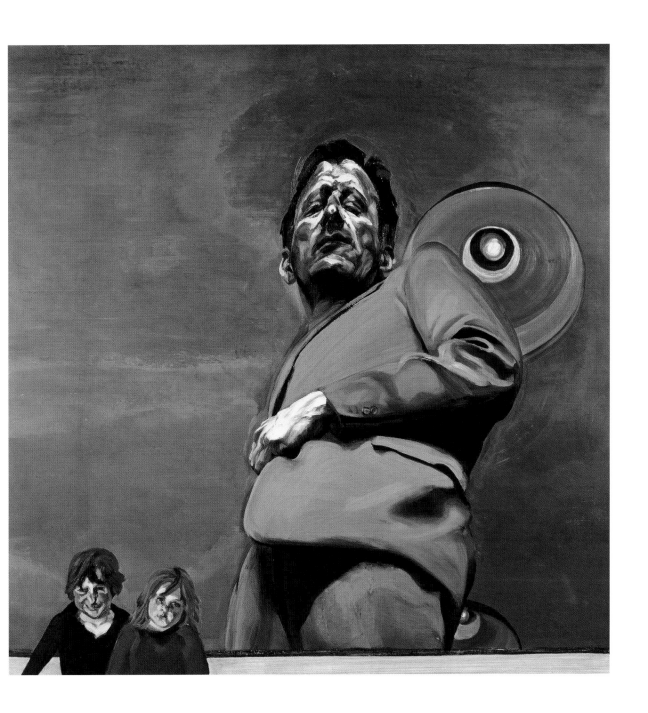

self-portrait

Acrylic and silk-screen on canvas, 182.5 x 182.5 cm
Private collection

For the second half of the 20th century, Andy Warhol epitomized the artist as "performer", who combines numerous professional functions (painter, printmaker, photographer, film director, advertising designer, manager, exhibition organizer) with image roles (picture icon, cult chimera, walking advertisement, partygoer). With partly genuine, partly pretended naivety, he raised the marketing of media events to the status of his artistic life's work. The lever for this often disarmingly uncritical-seeming, but in no way just cynically meant glamour interest was, for Warhol, the aestheticization of consumption and myth. (Consumption here means the standardization and commodification of well-being, and myth means everything that captivates the visual worlds and desires of the public through the omnipresence of technological images.) "Media consumption" is then also the central content of Warhol's art. In consequence his own myth, guaranteeing his embodiment of a type and his recognizability, had to be important to him. And indeed, no other artist before him, not even Dalí, knew how to apply the technological aura of photo and film so comprehensively to the presence and effect of his own person.

Self-portrait of 1967 is one of a silkscreen-print series comprising about 14 colour variations. The pictures, which were each created in four serigraphic processes, were marketed either as individual objects or combined in multiple block montages. The underlying pictorial principle is always the same: four colour stencils are printed over each other in such a way that the original photograph creates a total picture in gradated polarization patterns in signal colours. This produces the typical "Warhol label", which seeks to achieve monumental effect through its large, painting-like format. An intermediate form is found which mixes the aesthetic of free colour-field painting with trivial figuration. In the case of his 1967 self-portrait, this means: the artist applies this intermediate form to his own image and gives it the stereotypes of the pose. Warhol's expression (or rather, what can be

immediately identified as "Warhol" from technoid chiaroscuro effects) poses in the role of the contemplative. While one half of the face is shaded, on the other half we can recognize the spread fingers in which the chin is resting, while the lips remain tightly shut. The artist is looking at us coolly aloof, as "cool" as the play of colours in the whole. Like a worker-by-brain, or, no less conceivable, like a film diva pretending to be deep in thought. Emotional profundity? If so, then only in the media refraction of his own surface.

Everything visible, for Warhol, is a surface phenomenon. But the fact that profound reflexions are still possible – even in the garish light of the camera and in the sum of stencilled effects – is something that, even if it was not the primary intention, could still be welcome to the artist. For every shadow, every photographic exposure, every blurred edge, is a possible reflex of intimations of mortality. Warhol certainly allowed such reflexions in his head at an early date, albeit only ever to smooth them away as unwanted. But the 1967 picture proves that, for all the superficial posing, not even superstars, maybe especially not superstars, can manage without references to contemplation and silence.

"… you only need to look at the surface of my pictures… that's me. тhere's nothing hidden behind it."

Andy Warhol, 1967

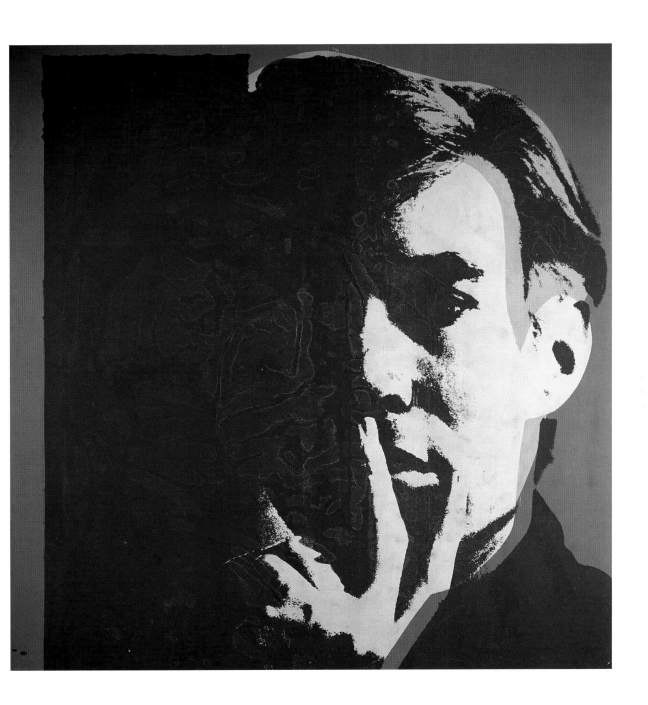

self-portrait

Oil on canvas, 198 x 147.5 cm
Private collection

Time and again in the 20th century the self-portrait, in order to be new and authentic, had to overcome the role-models of the past. In the process, time and again, these role-models were revived, but as though in a distorting mirror.

Francis Bacon's numerous and many-faceted self-portraits were not by any means influenced just by Picasso and 19th-century experimental photography (Muybridge), they owed almost as much to the movement forms of Rembrandt or the realism of Velázquez and Goya. Bacon was a representative of modernism who drew entirely on the present-day spirit of crude Existentialism to create an image of himself, and of himself as human being. His œuvre is inspired, or rather plagued, by abyssal doubts concerning metaphysical goals (God, idea, harmony) and the basic values of civilization (humanity, progress, justice). Time and again in numerous interviews, he berated the senselessness of the world with sarcastic contempt. And yet there were for him elements of the purpose of life to which he passionately devoted his whole work. These were the moments between fear and desire, in which life gets drunk on itself. And precisely the self-portrait, which – with its latent tendency to the confessional has always provoked questions of meaning and purpose – has proved itself time and again in this context. The question was always: is it possible to visually capture the decay of the identity of the modern psyche? Bacon's answer was that it *is* possible, provided no attempt is made at a merely illustrative treatment of individuality. Our example, which dates from 1973, makes it clear what he considered had to be done instead.

The artist is sitting in an empty room. But it is no ordinary seated posture. He twists his body in such a way as to suggest he were being tortured, and even the conventional Thonet bentwood chair looks more like the rack. It is as though every moment spent sitting there were intolerable. The face too is twisted, and the colours have run: its bony structure dissolved in smears, the hair, mouth and eyes all wild. Details leap out at us in penetrating clarity, gymshoe, wristwatch. The light-switch on the wall with the vertical line of the cable belongs no less matter-of-factly in this situation than the monstrous body in the middle or the theatrical ambience, its two-dimensionality recalling the flats of a stage-set. Edges meet chords, rigidity meets rotation. All this captivates our eye in a double sense. It attracts, it repels. It marks boundaries behind which driving forces and centrifugal forces build up. The context of body, space and surface is there, to be sure, but only with painful hardness and even more painful penetrations. While the parquetting forms a floor pattern of oblique parallels, in the left foreground, following the lines of the floor, a pile of papers, some written on, some printed, has collapsed, the sheets no longer confined to the picture.

As an individual, Francis Bacon is barely recognizable in this picture, at least outwardly. But his inner world has composed itself here. It has become a parable for the chaining of an unbridled vitality and for its outbreaks. Bacon's psychological state thus becomes a mirror of modern existential feelings. Every beholder can recognize this situation in him or herself when undergoing these feelings of being caged in. And these feelings are what it is all about. Bacon's likeness seeks to be captured inwardly, it seeks to overcome all resistance to be shared and communicated.

"I've done a lot of self-portraits, really because people have been dying around me like flies and I've had nobody else left to paint but myself."

Francis Bacon, interview, c. 1973

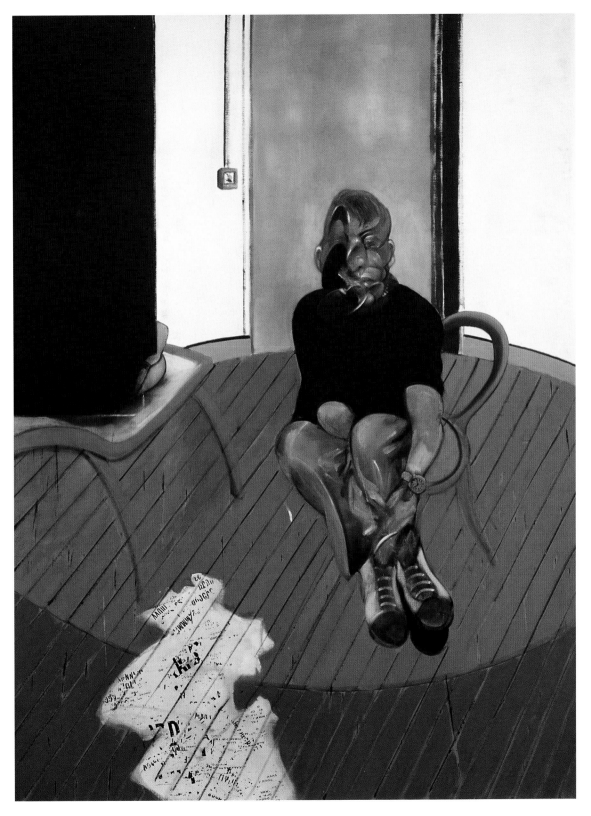

self-portrait with вlue guitar

Oil on canvas, 152.4 x 183 cm
Vienna, Museum Moderner Kunst Stiftung Ludwig, on loan from Sammlung Ludwig, Aachen

Artists at the end of the 20th century were not just characterized by the rejection of language and by self-staging. Artists are not just pioneers of inwardness. Sometimes they still embody in an entirely traditional fashion the idea, born in the Renaissance, of the *pictor doctus,* the learned interpreter of creative activity who, from the sheer pleasure of knowledge and thought, explains what he is doing.

The Englishman David Hockney, painter, graphic artist, draughtsman, photographer, author and teacher, is one of these painting intellectuals who explain themselves and their work through words and pictures. The fact that occasionally, in a way that recalls Andy Warhol, he pretends that he paints his pictures "just like that" alters nothing in this assessment. He knows perfectly well that art is always based decisively on other art, ancient and modern. Innovation is not least the targeted confrontation with what has been handed down.

Hockney's virtuosity consists precisely in that he makes visible the lines of tradition and the sources of his art, sometimes as parody, sometimes as quotation, always with lightness of touch. This seemingly uncomplicated, but in truth highly reflective, turning towards the complaisantly superior "easy-going" is what secures him a leading position among the exponents of English Pop Art.

Hockney painted his *Self-portrait with Blue Guitar* in 1977. But where in this picture is the guitar? And in what sense is it blue? At first we are struck by the dissociation of the pictorial elements and motifs. The artist, in a fashionable striped pullover, is sitting at his studio table, drawing. He is surrounded by things and shapes. The table looks as if it were made of synthetic imitation marble, the lines of the chair are austere, albeit neither shadow nor perspective "fit". Carpet elements on the floor evince austerely ornamented patterns without material substance.

The architectural forms on the rear wall, and the markers floating through the room, form a mere compositional scheme in geometric patterns. A bust in the style of Picasso stands on an abstractly stylized window-sill, in front of which "hangs" the mysterious fragment of a trellis. Everything is light and airy, sometimes merely hinted at, sometimes partly executed in detail. There is a playful mixture in the formal characters too: here something of the planning coolness of an architect's office, there something from the world of fashion design. The artist has executed himself in more detail, which draws attention to his being immersed in his work. Tulips in the vase next to him are likewise to be included among the plastically rounded things, while recalling the world of still-lifes. Halfway between two-dimensionality and three-dimensional illusion are the jars of paint on the table. And totally three-dimensional, more material than anything else in the picture, is the edge of the blue curtain, which, following the principles of Baroque *trompe l'œil* painting, demarcates the pictorial space from the space in front.

This montage is less concerned with things than with their signs and limits, and thus also with the position of the artist. He is at the centre of visibilities. For it is his creative competence that mediates between the original idea for the picture (guitar) and the reality principle (curtain). While the artist never determines alone how reality can be seen and thought, he is often the crucial factor. Thus the blue guitar is still in the outline stage beneath Hockney's hand, while its colour, still absent, though already present in the curtain, must be added in the mind of the beholder.

"ı think ı know myself reasonably well.
ı think first of all you'd have to be a little
more alone to do it and deal with it…"

David Hockney, interview with Marco Livingston, c. 1980

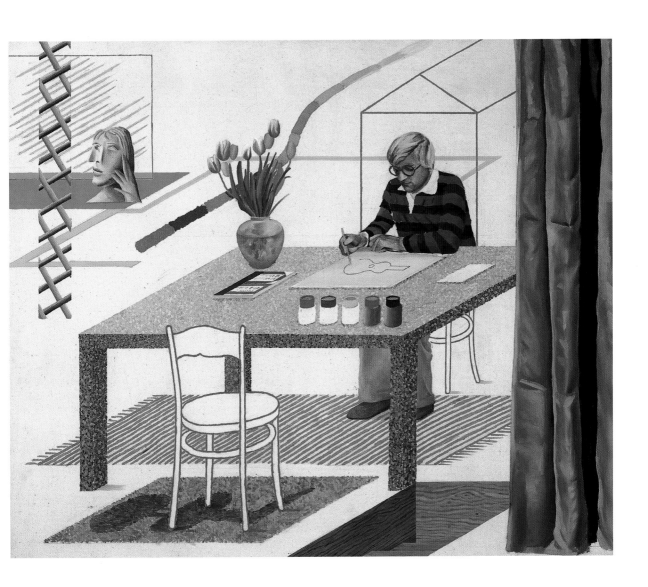

self-portrait with palette

Oil on canvas, 180 x 180 cm
Private collection

Actually, Albert Oehlen's *Self-portrait with Palette* is an entirely traditional example of the genre, at least as subject and programme. It shows the half-length figure of a painter in three-quarter profile, considering his next move. Palette and brush are in his hands, while lodged theatrically in the crook of his arm is a skull. The motif is one of a profound mind reasoning over the question: to be or not to be? Thus immersed in himself and in his mission, listening to his inner voice, the man with the straight parting and small moustache is staring into space. He is wearing an overall shirt with a large check pattern, such as might have been used a hundred years ago by Arnold Böcklin, who also employed the death's head as a professional attribute. Another pointer to erstwhile symbols of the beyond is the curtain, whose drawstring, gathering the folds, leads directly to the palette. The way is wide open to a dark room to the side and behind: the painter is the magician on the border between visibility and invisibility.

Naturally no beholder today would hit upon the idea of taking seriously the 1984 picture in this importunate attitude of self-explanation, let alone of giving it a traditional interpretation. Anyone who actually did so would be falling into the irony trap. No, this "self-portrait" draws attention to the explanatory sound and fury of the art business in such a way that almost any attempt at explanation would make itself ridiculous. But that is precisely the point. The real purpose of Oehlen's painting is to confuse every interpreter, indeed, interpretation itself.

In fact it is by no means so difficult to avoid the dilemma of these pieties. All one has to do is stick to what is obvious in the pictures – and as an art-lover, not take oneself so seriously.

The format of the picture and the figure is over-life-size. Any half-length is ridiculous, it would be an election poster or a cinema advert. In fact the curtain is reminiscent of the cinema and the sentimentality industry. Its yellowish-orange, striking in its juxtaposition to the dirty grey, comes across as if lit up from below by coloured lamps.

Intentionally clumsy, because it is pseudo-contrived, the ghostly white-lined cage floats between the figure and the curtain. A quote of a quote ("Captivity in the visions"?): Bacon, Polke, Kiefer, Salle have used signs like these, each in his own way. But Oehlen, the mocker, plays with the idea, because he not only wants to make fun of the heavy museum culture of the heroes of tradition, but also, and to hardly less an extent, the precocious fame of his own contemporaries. For Albert Oehlen seeks above all to play with effects, seeks to play the effects of *all* art against himself. In the process, though, the material returns with a vengeance. In particular, the substance of the paints is striking. Their dissonances are only painful for those who seek to recognize in their ugliness not significance, but another beauty. It would be the aesthetic of illuminated signs, comics, technical design, of the detritus of civilization, of conformist outfits. But Oehlen is not just ironic, he is also witty. On the palette, close to the carrot-like finger, we can see two eggyolk-yellow splodges. Nowhere else in the picture does this yellow occur. In this way, the coloration plays lustily with relationships and self-worth. Pleasure in colour and form cannot in itself be ironic, after all.

> "All the aches and pains of art lead back to the attempt, the half-hearted attempt, to kill it and thus to give it some validity."
>
> **Albert Oehlen, 1986**

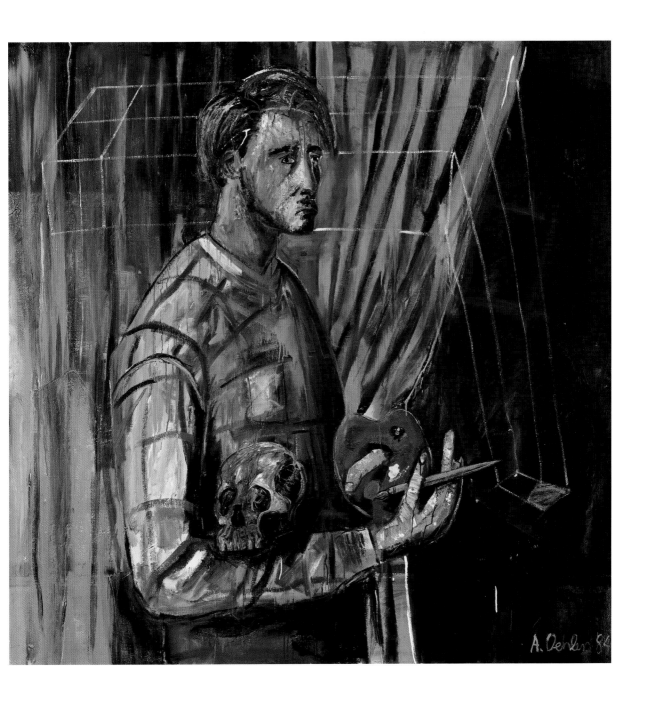

untitled

Oil on canvas, 240 x 200 cm
Private collection

It is not only in their basic concept that Kippenberger's pictures resemble those of Albert Oehlen. In German painting of the 1980s Martin Kippenberger, Albert Oehlen and Werner Büttner formed an artistic focus of their own, from which emanated various action programmes (catalogues, music CDs), clearly often working together. To this extent they represent a particular tendency within the "Neue Wilde" (Neo-fauves).

Their programmatic idea was: art with its innovations can only liberate itself if it makes transparent its sometimes exaggerated, indeed megalomaniac illusions of its own significance. And it must do this by taking *ad absurdum* the market mechanisms driving it in this direction. If you choose your moment in the economic cycle, with a bit of luck you can have success in precisely this market. Irony, including self-irony, is the key to success. And this irony must come from within, it must not consist only in defamiliarization and turning things on their head, but must rather use its own means to be creative. It must not spare any field of life or culture, it must track down the idiocy behind every slogan, the hypocrisy in every morality, the seed of madness and triviality in every oh-so-significant item of culture.

This total irony is not presented in a spirit of binding commitment, let alone with a demand for political consistency, but rather in art's own free and cheerfully subversive game of self-destruction. In Martin Kippenberger's case this game had a totally existential character: his early death in 1997 was due to alcoholic excesses.

His 1988 self-portrait is intentionally titled *Untitled.* Usually, after all, his works live by those qualities of parody which find their expression in verbose and clumsy titles. "Untitled" here means, then, that speechlessness and stylelessness can also stand for speech and style; that quotation and mockery are bearers of serious reflexion even where to all appearances they are anything but serious. The composition follows accordingly. Small if anything and shifted to the side and the bottom of the picture, the painter is standing in front of his "creation". Before we have a chance to reflect on this, the meticulously modelled, anatomically and carefully unsuccessful plasticity of a man dressed only in passion-killer underpants compels a "pitying" smile. He stands there paunchy, unsophisticated, stubble-chinned, with the worried expression of someone who, so to speak, has just opened a fridge door to find that there are no drinks. Painted in luminous colours on flat stone-grey and mustard-yellow areas is the mysterious cage in front of him, with which the man in the underpants is thoughtfully tampering. Evidently what we have is the free interplay of things, forms and quotations. We could identify a playpen, a winding-tower, a walking-frame, a hamster's cage. It is all "heavy" and delicate at the same time. Embedded in the middle is the familiar political emblem of the "hammer and sickle". The sickle in turn is mutating into the "sun of freedom".

Kippenberger previously modelled these motifs sculpturally in nonsense-designs. The mobile cage was deployed in front of the door of a Cologne publishing house as a monumental briefcase-holder, the hammer-and-sun sculpture as an ersatz pot-plant. Thus a meaning is thrown together from numerous components, but this meaning can only be interpreted by those who venture into the cage. The artist as joker and trap-setter is standing by. He is pulling the strings, combining in one person the roles of meaning-bestower and meaning-denier.

"To find a style of my own took me a long time until it struck me that being styleless is also a style, and this is what I then pursued."
Martin Kippenberger, 1996

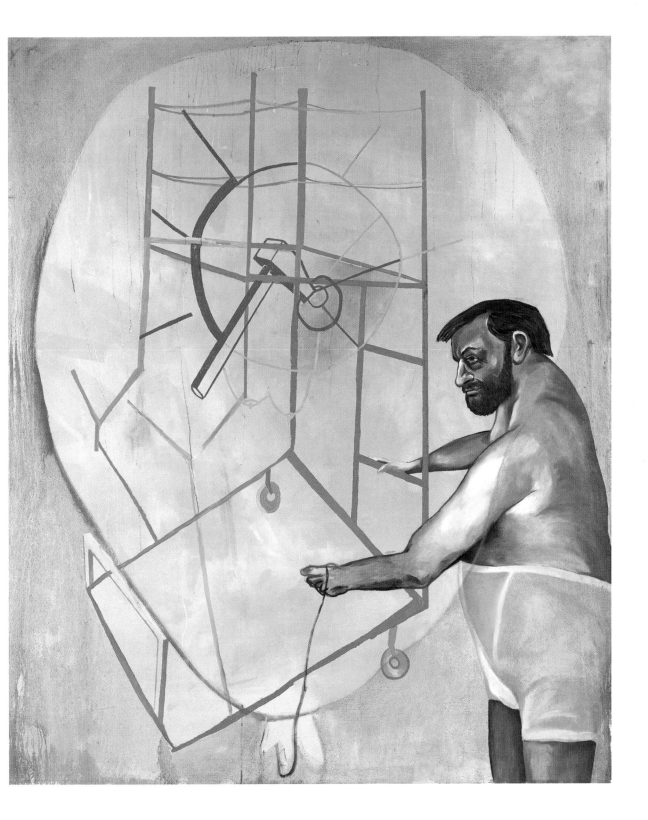

Ilona with ASS up

Oil inks on canvas, 243.5 x 366 cm
Private collection

Jeff Koons has designated himself the artistic heir of Andy Warhol. What he meant by this is that he has continued the affirmation of the consumer and media world of the 1960s and 70s, but raised it to a new conceptual level. Like Warhol, he asserts that the real purpose of art is a wholehearted acceptance of reality, and, transcending mere signs, the pursuit of the everyday. But Koons is more radical than Warhol in his acceptance of pleasure and material. For him, beauty as actual bliss is contained in all things and moments, not just in those of art. This may involve household appliances, whose design and use captivates our eyes and hands in the pleasure occasioned both by our abstract perception of them, and by their concrete utility. By this criterion, kitsch and luxury also deserve unqualified acceptance. As does, unreservedly, that which captivates our senses more strongly than anything, but which, owing to moral blocks, is enjoyed too little, while being cynically demoted via the media to the status of vicarious satisfaction: sex. According to Koons, we have to respond with a demonstrative upheaval in values, and art is, he says, precisely the appropriate sphere. Take the example of pornography: it should not be demonized, but rather, by conscious perception, transformed in such a way that the whole of existence is "sexualized" by it without regard to things, values and feelings. In return, a disburdening desexualization of the sexual is achieved.

In 1989 Koons got together with the Italian porn-star Ilona Staller, alias Cicciolina, in order to stage, with her, so to speak, as "ready-made", a direct model of positively revalued pornography. Cicciolina for her part was interested in this project, because, recently elected to the Italian parliament, she was also agitating politically for "sexual liberation". The two of them (who then fell in love and got married in 1991, before divorcing the following year, and thereafter waging an endless media war against each other) had a series of large-format photographs taken of themselves. The depiction of their unsimulated sexual intercourse (titled *Made in Heaven*) was exhibited several months later at the Venice Biennale.

The great success of the works was assisted by the execution of certain pictures as sculptures in wood and porcelain. Koons and Staller functioned as the new Adam and Eve in a lusty double coding. Many a burdensome contrast now came across in a new light: shame and shamelessness, publicness and intimacy, the heaven of pleasure and the hell of morals, true fact and illusory surrogate. Jeff Koons became the vicarious enjoyer. He showed himself to be an artist whose creativity lay in the overcoming of fictions, albeit an overcoming whose success depended once more upon images, in other words: fictions. To the extent that sex was represented at the same time both as exhibitable commodity and as an extendable metaphor for happiness, old fantasies were taken up with new means.

Objectively, pornography; functionally, art? Expelled from Paradise, back into Paradise? Whatever: Koons the pleasure-pioneer knew that in the present-day art-business, success potential is exploited ever more sensation-hungrily. Exhibition and exhibition are mutually subsumed, willy-nilly.

"In this series we adopted in a sense the roles of Adam and Eve."

Jeff Koons, interview 2007

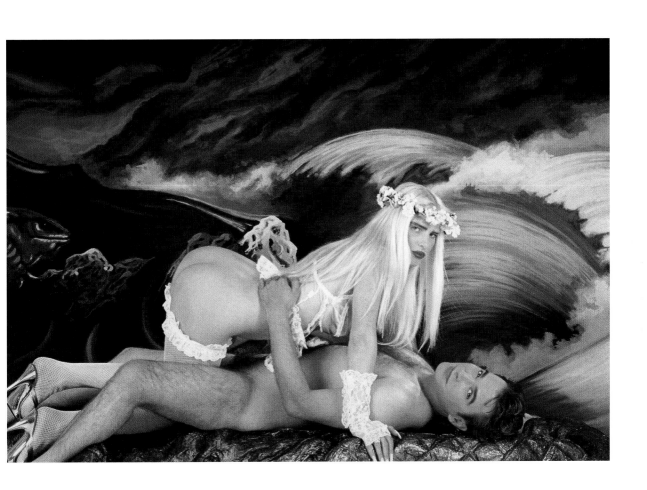

court chapel, Dresden

Oil on canvas, 80 x 93 cm
New York, The Museum of Modern Art, promised gift of Donald L. Bryant, Jr.

An amateurish out-of-focus photo, that might be our first impression, with faded colours to boot. And if we weren't immediately aware that it is not a photo, but a painting, a typical "Gerhard Richter", we would necessarily be puzzling about the aesthetics of such a banal oversize snapshot, badly composed and so badly shaken as to be unusable. However by now Richter's painting concept, painterly blurring, has become the signal of stylistic recognizability. Since 1962, Richter has built up a huge collection of photographic prints and other pictorial material. For Richter, the internationally best-known contemporary German painter, it became the foundation of his art. While the translation of photos into paintings constitutes only part of his œuvre, this part was and remains representative of the whole. What direct information, how much background knowledge necessary for an understanding of the picture, can one obtain from the present image? Here too it must be said: if we didn't know from external sources that the shorter of the two pale male figures was the artist, we would be all the more dependent on the painting and nothing but the painting. The colour timbre is as cold as the upturned collars of the coats of the two men suggests it was in reality when the picture was taken. The massive wooden door takes up more space than the couple of men in front of it. In the wan, blurred brightness of the frozen smiling faces is preserved a remnant of the flesh colour to recall the colour-film status of the "original".

Fading memory? Or should the photographic fading even be continued up to a certain point by painting? Painting is always both the precise form of forgetting in appearance and yet at the same time its monumentalization in the picture. That is exactly how the painting comes across, and accordingly we can follow the process of its creation. A slide projector projected the colour slide on to the screen, and thus enlarged it. Richter then painted it with brush and paint, altering it, and finally while the paint was still wet, gently blurring it using a broad brush with long hairs.

Thus the elements were finely fused, the trench coat grey of the overcoat merged with the oaken brown of the door. The smiles of the two bespectacled old men retain just about as much graphic clarity as the profile of the door-panels. It's all painting. It is equally present in every part of the picture, and nowhere "out of focus". For, as Richter has emphasized time and again, painting cannot be out of focus.

The man beside Richter is his long-time friend, the art-historian Benjamin H. D. Buchloh. In 2000 the two went on a trip to former East Germany, including a visit to Dresden, where Richter was born, and where they had themselves photographed standing in front of this door. A "friendship picture" (Stefan Gronert 2005) and a souvenir, then? And a self-portrait? With his media transformation, Richter blurs the boundaries of the old disciplines. While he clings fast to painting as medium, he concedes few special rights to the themes. Every painting is self-portrayal, or it is no longer painting.

> **"I have always wished to be able to paint good portraits, but that is no longer possible. I am more concerned to paint beautiful pictures."**
>
> **Gerhard Richter, 1995**